IMAGES
of America

BUILDING
ROUTE 128

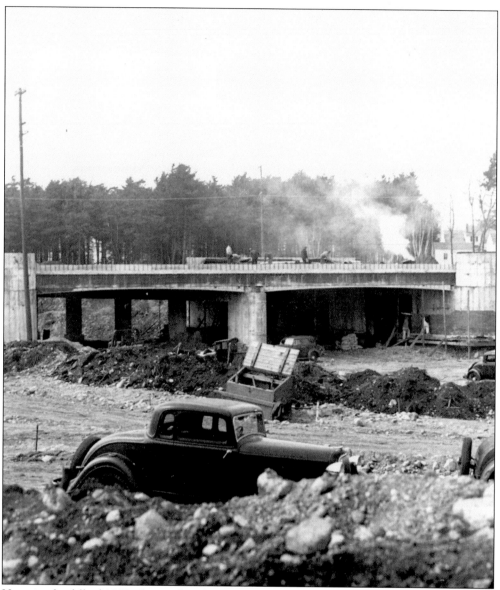

Here, in the fall of 1937, the steel and concrete bridge structure that will carry Route 1 over the new Route 128 in Lynnfield has been completed and stands ready to receive its decorative brick and stone facade. This interchange between the busy Route 1 and the double-barreled Route 128 was among the earliest examples of the modern cloverleaf layout constructed in Massachusetts. (Courtesy Warren Falls.)

IMAGES
of America

BUILDING
ROUTE 128

Yanni Tsipis and David Kruh

ARCADIA
PUBLISHING

Published by Arcadia Publishing
Charleston, South Carolina

Printed in the United States of America

Library of Congress Catalog Card Number: 2002116260

For all general information contact Arcadia Publishing at:
Telephone 843-853-2070
Fax 843-853-0044
E-mail sales@arcadiapublishing.com
For customer service and orders:
Toll-Free 1-888-313-2665

Visit us on the Internet at www.arcadiapublishing.com

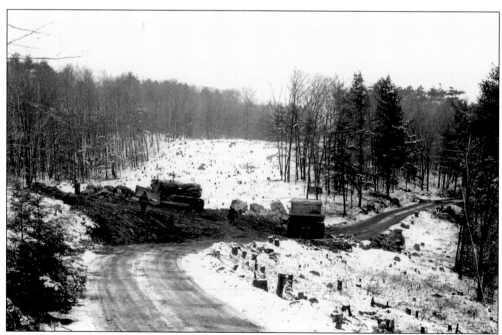

In this December 1951 view, heavy equipment works to clear the Route 128 alignment through the low rolling hills near Haskell Pond in western Gloucester. Providing adequate job-site access was a major construction expense in many of the remote locations through which the new highway passed, especially on the North Shore. In this area, a rudimentary dirt road linked the site to Forest Lane and Route 133. (Courtesy MSA.)

CONTENTS

ACKNOWLEDGMENTS

Condensing the history of one of the Commonwealth's most complex and influential public works projects into this slim volume was a task made possible only by the generous assistance of the following: Carla Abate, Susan Abele of the Jackson Homestead, Victoria Adams of the Reading Historical Commission, Albert Arena of the Waltham Museum, Gerald Blakeley, Joe Brown, John Cogliano and Doug Cope of the Massachusetts Highway Department (MHD), Michael Coleman of WBZ Radio, Michael Comeau and Elizabeth Marzuoli of the Massachusetts State Archives (MSA), Henry Cook of the Randolph Historical Commission, Herb Crawford, Martin DeMatteo of DeMatteo Construction, Jay Doherty and Kara Phillips of Cabot, Cabot and Forbes (CC & F), Mary Englund, Rick Englund, Warren Falls, Tony Faria, Victor Gail, Jim Gallagher of the Boston University Beebe Library, Richard Gonnam, Samantha Grantham, Richard Kollen of the Lexington Historical Society, Norman Krim, William Litant of the Massachusetts Institute of Technology, Town of Burlington archivist Daniel McCormick, Kaia Motter and Amy Sutton at Arcadia Publishing, Robert Peary, Richard O'Rourke, Ester Proctor of the Manchester Historical Society, George Sanborn of the State Transportation Library, Aaron Schmidt of the Boston Public Library, Roberta Sullivan of the Reading Historical Commission, Dan Young, and Janice Zwicker of the Waltham Public Library.

The authors would like to give special thanks to Alex Bardow at the Massachusetts Highway Department's Bridge Section, whose technical expertise and assistance proved invaluable to the preparation of this work.

David also wishes express his gratitude to his wife, Mauzy, and daughter, Jennifer, who took many trips with him up and down Route 128 as he researched this book.

—Yanni Tsipis and David Kruh

One

THE OLD ROUTE 128

On January 1, 1906, John F. Fitzgerald became the first mayor of Boston to ride to his inaugural in an automobile. By the time Fitzgerald won his second term as mayor in 1910, some 31,000 automobiles were registered in the Commonwealth, or about one per 100 state residents. Their limited number, however, belied the magnitude of the automobile's early impact on the thinking of city and regional planners in the pre–World War I era. Downtown, city planners drew up grandiose plans for a major vehicular thoroughfare between North and South Stations, intended to provide relief from traffic congestion and to facilitate speedier regional travel through the city. Outside the city, the Metropolitan Park Commission embarked on an ambitious new program of parkway construction that complemented its early urban parkways and was designed explicitly to provide access to large recreation areas like the Blue Hills Reservation, Middlesex Fells, and the Lynn Woods. The Metropolitan Park Commission described these parkways as a "beautiful, convenient, and complete system of . . . main thoroughfares for the [metropolitan] District."

Originally planned with pleasure travel in mind, the new parkway system was rapidly adopted by motorists as the metropolitan area's principal highway network. Even the Metropolitan Park Commission itself quickly recognized this shift. "Now that automobiles have come into such general use," reported the commission in 1911, "it is hard to imagine what the District would do without these arteries of travel." What made many of the Metropolitan Park Commission's new and proposed roads (and those of its Metropolitan District Commission successor) unique was their tendency to run circumferentially, linking major parks and existing radial parkways on the periphery of the metropolitan area. While the Massachusetts Highway Commission—and, after 1919, the new Massachusetts Department of Public Works—remained focused on the construction and maintenance of radial routes that linked the core city to its surrounding suburbs and farms to markets, the Metropolitan Park Commission's less transportation-intensive core mission of developing a system of interconnected major parks caused it to unwittingly blaze a trail to the future of transportation and land use in metropolitan Boston.

In 1925, the federal Bureau of Public Roads (the predecessor of the Federal Highway Administration) began to establish a rudimentary network of virtual interstate routes by assigning federal route numbers to existing state highways that, when connected on a map, would traverse several states. To complement the federally designated routes, Massachusetts Department of Public Works engineers, under the direction of project engineer Franklin C. Pillsbury, somewhat haphazardly assigned numbers to state routes that were not included in the federal system. Most of the state route numbers described roads directly radiating from or connecting major urban areas, or traversing major portions of the state. One remarkable exception to this pattern marked the beginning of a highway planning paradigm that would touch almost every major American metropolitan area in the second half of the 20th century—the circumferential beltway. This original Route 128 was not the product of any deliberate plan or careful transportation study. Rather, this most influential of routes appears to have been the creative construct of public works officials, who simply applied a state route number to a chain of existing local streets that roughly reflected the Metropolitan District Commission's circumferential concept. By the late 1920s, Route 128 began appearing on highway maps of the Commonwealth as an almost untraceably crooked path through Boston's suburbs, from Hull and Hingham in the south, west through Newton and Waltham, and north to Danvers and Beverly.

Although unified on paper by their new designation, the local roads that made up the old Route 128 varied widely in capacity and quality. For a brief stretch on Montvale Avenue in Stoneham, for example, motorists enjoyed a broad avenue with two lanes in each direction.

Through much of Newton, by contrast, a single heavily traveled lane of traffic in each direction made traffic conditions especially arduous. Although traffic increased only gradually on the newly designated route through the early 1930s, in many of the older and denser suburbs to the north and west of Boston, even the modest incremental volume led to a serious deterioration in traffic conditions on downtown main streets whose alignments and design standards dated to the days of the horse cart. This phenomenon was especially pronounced in the towns adjacent to the Newburyport Turnpike (Route 1), which had been reconstructed in the mid-1930s and funneled traffic bound to and coming from the Cape Ann region onto the narrow streets of the old Route 128 in Lynnfield, Peabody, Danvers, and Beverly.

By the early 1930s, Massachusetts Department of Public Works engineers had conceived of a relocated, modernized Route 128 constructed outside of the dense town centers that wrought such havoc on the still modest flow of circumferential traffic on the existing route. The new route was described in contemporary reports in two parts: the "Northern Circumferential Highway," snaking its way from Wellesley north to Gloucester, and the "Southern Circumferential Highway," which continued south from Wellesley to Braintree. Although far-sighted, these plans began to mature on the department's drawing boards during an era when the Commonwealth's already limited highway funds were routinely diverted to support social programs and statewide property tax relief. As a result, construction of the new Route 128 did not begin until the summer of 1936, and even then, only on a short stretch between Route 1 in Lynnfield and Lowell Street in Peabody at a cost of just under $900,000. For each of the next few years, Route 128 grew by a few short miles as new highway appropriations became available. By 1941, when the entry of the United States into World War II brought highway construction nationwide to an abrupt halt, the new highway had been extended west to the Wakefield-Lynnfield border and east through Danvers. Shortly after the war, the fiscally constrained program of piecemeal construction began again, adding short sections of Route 128 in Beverly and Wakefield by 1949.

The inauguration of Democrat Paul Dever as governor of Massachusetts in January 1949 set in motion a rapid chain of events that would result in the most extensive program of highway construction that the Commonwealth had ever seen. Dever enjoyed the first-ever Democratic majority in the Massachusetts House of Representatives, which at Dever's urging swiftly passed an unprecedented $100 million bond bill, funded by an increase in the statewide gasoline tax and earmarked exclusively for major highway projects statewide. Dever also urged the legislature to reorganize the state's department of public works to eliminate what he called "cumbersome and unnecessary procedures" that would, he argued, slow the progress of the statewide highway-construction program. Rather than rely on a lengthy reorganization initiative to speed his highway plans through the maze of department of public works red tape, however, Dever opted instead for a simpler means of achieving the same end by giving the task of turning newly appropriated highway funds into new highways to William Callahan.

During a previous tenure as commissioner of the Massachusetts Department of Public Works from 1934 to 1939, Callahan had overseen the modernization of the Newburyport Turnpike and the Herculean task of rebuilding hundreds of bridges and roads washed out during the Great New England Hurricane of 1938. Callahan earned a reputation as the Commonwealth's most prolific and efficient road builder during an era of severe fiscal constraints. By contrast, when he returned to office in the spring of 1949, he found that the once meager trickle of state highway-construction money had turned to a torrent. A powerful union of political, social, and economic forces had made highway construction a top priority for the Dever administration, which would approve $400 million in highway construction money between 1949 and 1952 alone. Endowed with unprecedented sums and a broad-based political mandate, Callahan began to plan the massive construction program.

Under past commissioners, the Massachusetts Department of Public Works had generally spread its annual highway appropriation among small projects across the state, a practice that satisfied legislators but precluded the construction of major highway projects with long durations

and geographically concentrated benefits. When he took office in 1949, William Callahan largely abandoned the old practice and immediately identified two major highway projects as his top priorities: the Central Artery in Boston's traffic-choked downtown and a 22-mile section of Route 128 between Wakefield and Wellesley. Together, these two projects consumed fully half of the department's $92 million share of the 1949 $100 million highway bond, the remainder of which went to the Metropolitan District Commission for the construction of Storrow Drive.

Callahan's priorities, however, were not without their critics. While few argued with the need for an expressway that would open downtown Boston to convenient automobile access, equally few fully understood the logic behind the construction of over 20 miles of modern expressway through Boston's sparsely populated suburbs. Even the federal Bureau of Public Roads refused to approve Callahan's plans to construct the new circumferential highway as a six-lane road because its engineers believed that four lanes would provide sufficient capacity for decades to come. Although Callahan had not conceived the idea of a circumferential highway ringing Boston, he was well ahead of many transportation planners across the nation (including longtime federal Bureau of Public Roads chief Thomas MacDonald) in recognizing the inherent link between highway construction, intensified land use, and economic development. "This new highway will cause the relocation of business establishments and open new residential sections," Callahan predicted in November 1949 just before letting the first construction contracts for what was then the single most expensive highway project in the Commonwealth's history.

Construction of the new Route 128 from the Lynnfield-Wakefield border (where it would link up with the previously completed sections of the highway) to its southern terminus at Route 9 in Wellesley began in the spring of 1950. Callahan split the enormous job into nine separate contracts, allowing work to begin and proceed almost simultaneously all along the route's 22-mile length. The strategy also served to control the overall price of the project by enabling many smaller contractors—who would have been unable to compete for the entire 22-mile project—to submit bids for the individual sections. The work of building Route 128 through the farms and low hills of what were at the time Boston's outer suburbs proceeded with few delays or complications, and within 18 months of the start of construction on the largest highway project the state had ever seen, Gov. Paul Dever—with Callahan at his side—cut the ribbon of the new highway on August 23, 1951.

In 1949, when Route 128 was still in the planning stages, federal Bureau of Public Roads chief Thomas MacDonald had insisted that the bureau's estimate of 15,000 vehicles per day on the new highway in 1970 was optimistic. The first full day the new highway was in operation, 18,000 vehicles traversed some portion of it. By 1954, the number had risen to 26,000.

William Callahan left the Massachusetts Department of Public Works to chair the Massachusetts Turnpike Authority before he could resume work on Route 128 south of Route 9 in Wellesley. His successor, John Volpe, had less difficulty convincing the federal Bureau of Public Roads and former critics of Callahan's "road to nowhere" of the merits of constructing the southern portion of the highway, which would link the existing four-lane road to the planned Fall River Expressway (Route 24) in Randolph and the Southeast Expressway (Interstate 93) in Braintree. Work on this southern section did not begin until the late fall of 1953, and it proceeded in stages reminiscent of the old prewar piecemeal process on the North Shore as annual highway appropriations were again spread thin across the Commonwealth. The last stretch of Route 128 to be constructed was completed in 1958, the same year that on one summer's weekend, more than 50,000 cars traversed the highway that had been built to accommodate 15,000. Even before work on the six-lane southern portion of the nascent highway had been completed, work had already been begun on widening the once underestimated road between Wellesley and Lynnfield.

This book begins with a trip around the old Route 128, the motley collection of local streets and byways that circumnavigated the Boston metropolitan area. It reveals the humble beginnings of the highway that would, within a few years of its completion, emerge as an unrivaled regional axis of transportation and economic development.

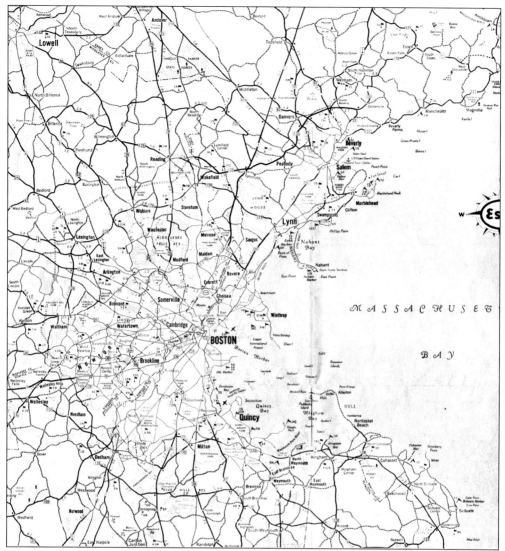

This map shows the state of the highway network in and around Boston c. 1949. The original Route 128 can be traced from Gloucester and Cape Ann in the northeast corner of the map west through Wellesley, Newton, and Needham and south to Braintree and Hingham, ending at Nantasket Beach in Hull. The map shows several sections of Route 128 in Wakefield, Lynnfield, Peabody, and Danvers that were constructed a few miles at a time between 1936 and 1941 and between 1946 and 1949. Also visible is the dotted outline of the new Route 128, the construction of which began in early 1950. The old Route 128 began as Essex Avenue in Gloucester and continued west through Essex, Hamilton, Wenham, and Beverly.

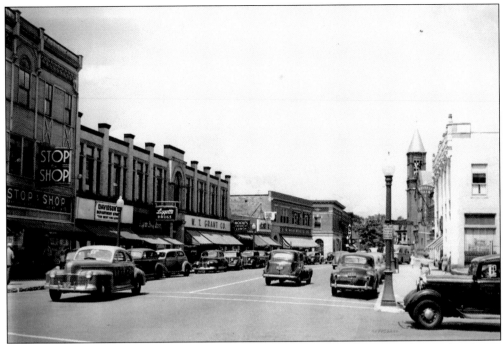

The old Route 128 passed into Beverly on Essex Street and then continued on Cabot Street south to Salem. This *c*. 1950 view looks north up Cabot Street in the heart of Beverly's business district, just south of the intersection with Essex Street. The spire of St. Mary's Church is in the background, and an early Stop & Shop market is visible at the far left. (Courtesy the Beverly Historical Society.)

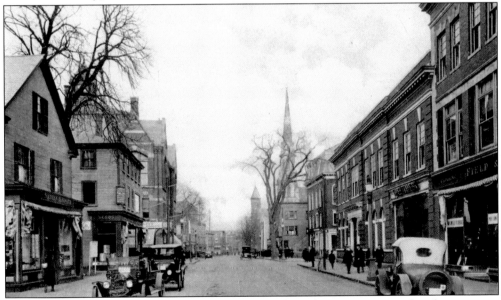

This *c*. 1928 view of Cabot Street looks north, as does the previous view, but from a point farther south along the old Route 128. St. Mary's, with its distinctive turreted spire, is just visible in the distance, and the First Baptist Church and the Beverly Town Hall are midway up the street on the right side. (Courtesy the Beverly Historical Society.)

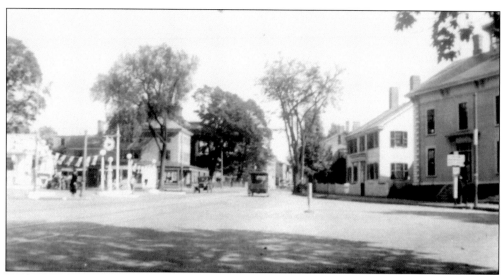

Farther south on Cabot Street, this view from the 1930s looks north from its intersection with Stone Street, a few blocks north of Beverly Harbor. One of many gasoline stations that sprouted up along the old Route 128 can be seen on the left, just south of School Street. (Courtesy the Beverly Historical Society.)

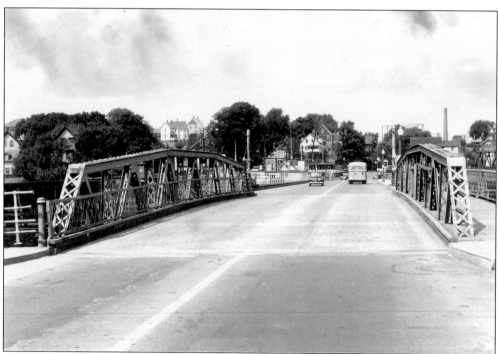

Cabot Street in Beverly crossed Beverly Harbor over the Essex Bridge and became Bridge Street in Salem. In this photograph taken in August 1946, we are looking north over the Essex Bridge from Salem back into Beverly. At the time, Cabot Street in Beverly and Bridge Street in Salem carried the Route 1A designation (which they still do today) as well as Route 128. (Courtesy MHD.)

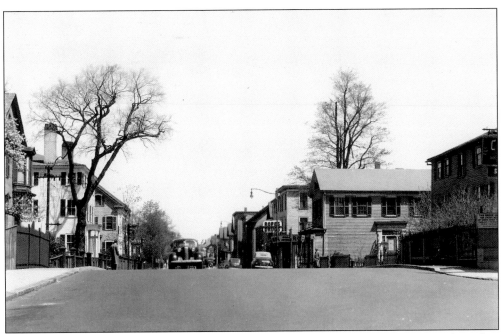

This May 1946 view looks north on Bridge Street in Salem, from the point where the Salem Harbor Branch of the Boston and Maine Railroad's Salem and Lowell line passed underneath. From Bridge Street to Boston Street, the old Route 128 then entered Peabody, where it used Main, Washington, and Lynnfield Streets before crossing into neighboring Lynnfield. (Courtesy MHD.)

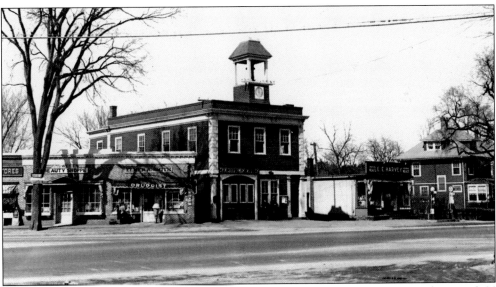

Shown in this photograph of the old Route 128 (Salem Street) in Lynnfield are the Lynnfield Beauty Shoppe and Elmer's Drug Store, to the left of the Lynnfield firehouse (the large building with the tower). To the right, E.E. Harvey's is a classic example of a business that went with the times. It was originally a meat and produce market, but gas pumps were eventually installed to take advantage of the store's strategic location at the intersection of two busy routes. (Courtesy Warren Falls.)

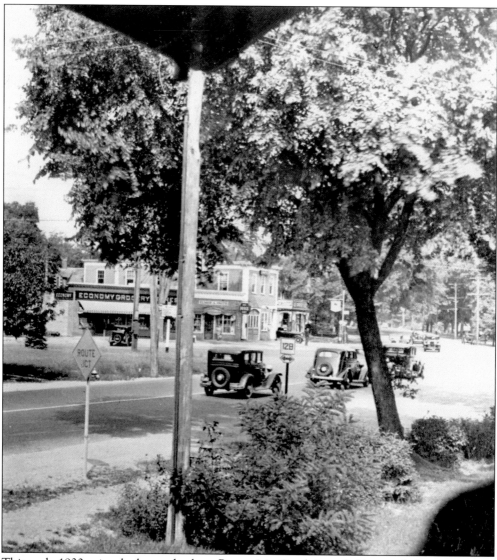

This early-1930s view looks north along Route 1 in South Lynnfield toward the intersection with Salem Street, which carried the Route 128 designation. Note the signs reading, "ROUTE JCT" and "128," on the near side of Route 1, which would be reconstructed along much of its length in the mid-1930s. This area, known at the time as South Lynnfield Square, would be made unrecognizable by the construction of a complex grade-separated interchange between Route 1 and Salem Street. The new Route 128, constructed between 1937 and 1938 in this area, passes just to the north of this intersection. (Courtesy Warren Falls.)

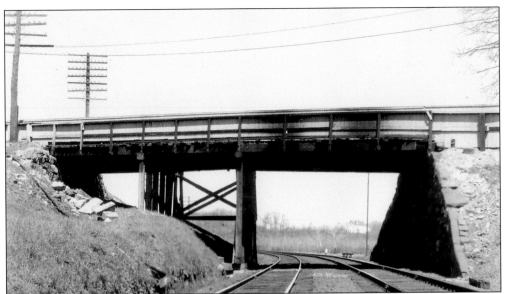

From Lynnfield, the old Route 128 continued into Wakefield on Salem Street, where it connected to New Salem Street, Vernon Street, Water Street, North Avenue, and finally Albion Street before crossing into Stoneham. It then followed Elm Street and turned south on Main Street and west onto Montvale Avenue, which carried it into Woburn. This May 1946 photograph shows the precarious-looking structure that carried Montvale Avenue over the Boston and Lowell line of the Boston and Maine Railroad in Woburn. (Courtesy MHD.)

The old Route 128 continued through Woburn along Main and Pleasant Streets before passing into Lexington on Lexington Street. This photograph, taken in the early 1950s, shows the Four Corners section of Woburn, where Lexington Street crosses in front of Mayflower Furniture, whose sign read, "25 years without a sale," and behind O'Rourke's Service Station, opened in 1934 and still in operation today. Cambridge Street crosses Lexington Street in front of O'Rourke's. (Courtesy Richard O'Rourke.)

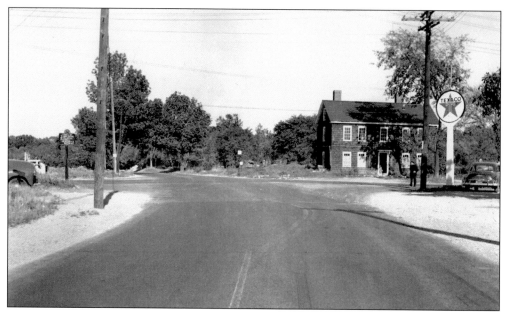

Lexington Street in Woburn became Woburn Street in Lexington. In this photograph taken on September 13, 1950, we are on Woburn Street looking east, back toward Woburn. This intersection featured Ye Olde Countryside, a restaurant, market, farm stand, and Texaco gas station, whose sign can be seen on the right. (Courtesy the Lexington Historical Society.)

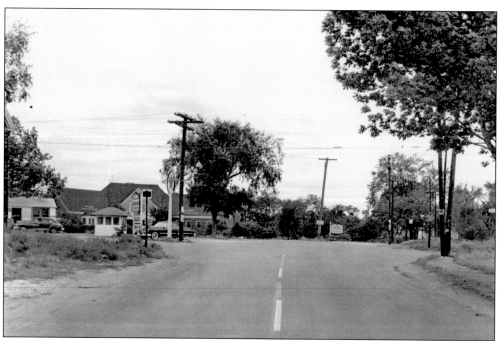

This converse view looks west along Woburn Street into Lexington at Ye Olde Countryside. This stretch of the old Route 128 was among the most lightly traveled, with an average daily traffic volume of 4,000 cars by the early 1930s. A section of the old highway in Stoneham, by contrast, carried almost 16,000 cars each day. (Courtesy the Lexington Historical Society.)

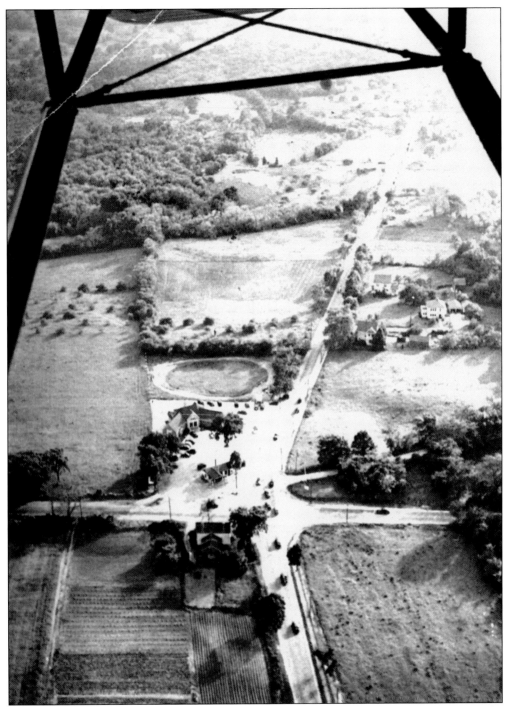

From the air in 1940, Woburn Street, which carried the Route 128 designation from the Woburn border into Lexington Center, runs from the bottom (north toward Woburn) to the top (south toward Lexington Center) of the image. The Ye Olde Countryside market figures prominently at the southwest corner of the intersection with Lowell Street. (Courtesy the Lexington Historical Society.)

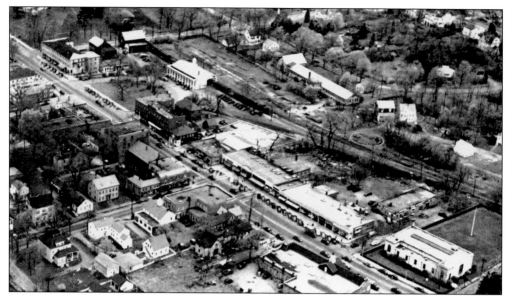

At the end of Woburn Street, Massachusetts Avenue took over circumferential duties for a few blocks. This 1947 aerial view shows Massachusetts Avenue as it passes through Lexington's main business district. The old Route 128 enters from the north (to the right in this image), continues halfway through the downtown section on Massachusetts Avenue, and then turns south (left) onto Waltham Street near the center of the image before continuing south into Waltham. (Courtesy the Lexington Historical Society.)

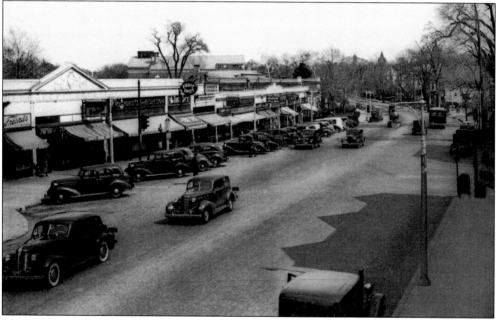

This view shows Massachusetts Avenue in downtown Lexington in 1938. Although many drivers used the old Route 128 as a regional bypass, local merchants (save for restaurant and gas station owners) did not derive many benefits from the designation. In fact, by the late 1930s, the heavy volume of regional traffic passing through the business districts of towns along the old Route 128 often hurt local service establishments. (Courtesy the Lexington Historical Society.)

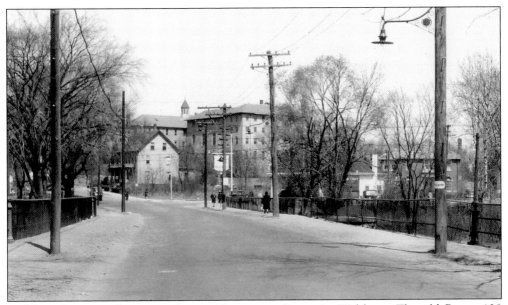

Waltham Street in Lexington became Lexington Street in Waltham. The old Route 128 followed a particularly arduous and treacherous route through the center of Waltham, including a quarter-mile stretch along heavily congested Main Street, after which it turned onto Newton Street, seen in this 1946 photograph, where it traversed the Charles River on a 19th-century stone-arch bridge. (Courtesy MHD.)

This view looks south in the late fall of 1947 from the point where Newton Street in Waltham passes over the Watertown Branch of the Boston and Maine's Fitchburg line. From Newton Street, the old Route 128 continued south with a turn onto High Street, after which it entered Newton. (Courtesy MHD.)

Once in Newton, the old Route 128 continued on Waltham and Crafts Streets before connecting to Walnut Street in Newtonville, shown here passing over the main line of the Boston and Albany Railroad in 1946. The Methodist church is at the left, and the neo-Gothic Masonic building remains a Newton landmark. The large riveted plate-girder bridges such as the one pictured here were once a common sight at many railroad crossings throughout the Commonwealth. (Courtesy MHD.)

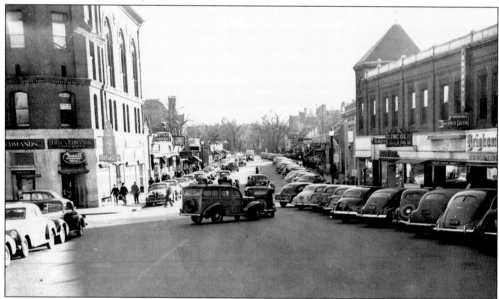

Taken just south of the bridge over the Boston and Albany tracks, this photograph shows Walnut Street as it passes through the village of Newtonville, with the c. 1896 Masonic building at the left. This two-lane stretch of Walnut Street was among the most congested sections of the old Route 128 during peak periods—a condition not captured in this image, taken on a winter's afternoon in 1946. (Courtesy the Jackson Homestead, Newton.)

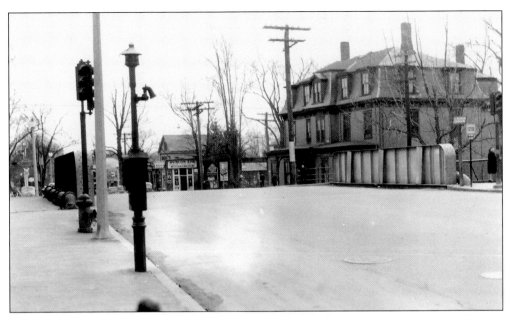

Pictured in March 1946 is Walnut Street in Newton Highlands, where it passes over the Boston and Albany Railroad's Highland Branch (today the MBTA Green Line's D branch). Note the Route 128 sign on the right side of the road. Just south of this point, Walnut Street was cut off by the construction of Route 9 in 1932, and the old Route 128 continued to the southwest on Centre Street. (Courtesy MHD.)

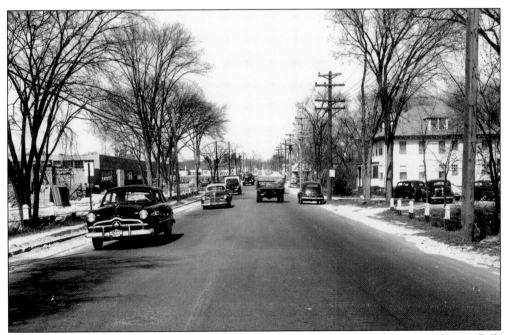

Centre Street passed under Route 9 and became Needham Street in Newton Upper Falls before continuing into Needham on Highland Avenue. Shown in a view looking north in May 1951, this stretch of Needham Street has only three months left, as the new section of divided highway from Wakefield to Route 9 would open in August. (Courtesy MHD.)

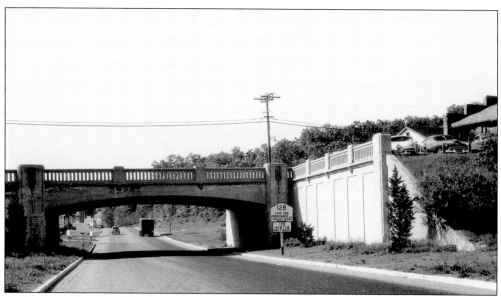

A short stretch of Highland Avenue carried Route 128 into Needham, where it crossed over Greendale Avenue, which took over circumferential duties south of the interchange shown in this southerly view from the spring of 1951. Of particular note at the right of this image is Muzi motorcars, founded in 1932 by John Muzi. When the interchange shown here was expanded beginning in late 1953, much of the original Muzi dealership was taken by the state. (Courtesy MHD.)

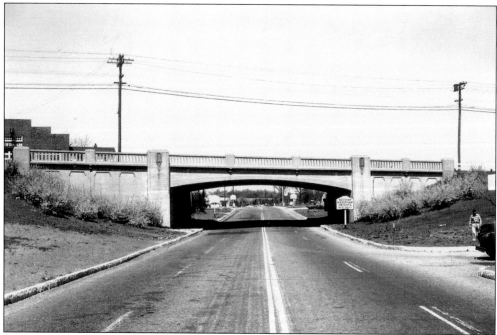

Here is a northerly view of the Highland Avenue overpass in Needham, with the Muzi dealership at the far left. This interchange, constructed in 1931, was one of the first grade-separated, limited-access interchanges built in the Commonwealth, predating their widespread introduction on the Worcester Turnpike in 1932. (Courtesy MHD.)

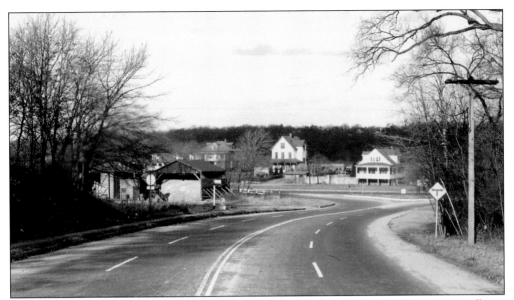

This 1949 view looks north toward Route 9 in Wellesley along Reservoir Street in Needham, which carried the Route 128 designation between 1951 and 1954. When the new Route 128 was completed to Route 9 in 1951, Reservoir Street connected it directly to the old Route 128 (Greendale Avenue) in Needham until the construction of the new highway south of Route 9 cut the connection in the summer of 1954. Compare this view to a similar one on page 96. (Courtesy MSA.)

Greendale Avenue continued south from Needham into Dedham, where it can be seen crossing High Street (Route 109) in this early-1930s view. The town of Dedham renamed Greendale Avenue the Southern Circumferential Highway on town maps starting in the early 1930s. The old Route 128 skirted the Dedham-Westwood border before passing into neighboring Canton. (Courtesy the Dedham Historical Society.)

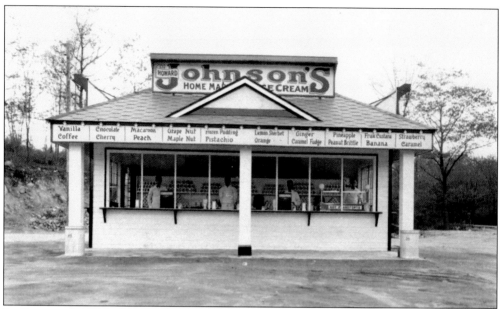

| Vanilla | Chocolate | Macaroon | Grape Nut | Frozen Pudding | Lemon Sherbet | Ginger | Pineapple | Fruit Custard | Strawberry |
| Coffee | Cherry | Peach | Maple Nut | Pistachio | Orange | Caramel Fudge | Peanut Brittle | Banana | Caramel |

In Canton, the old Route 128 turned onto Blue Hill River Road, which skirted the borders of Milton, Quincy, and Randolph as it crossed eastward through the Blue Hills Reservation. This view shows one of the country's first Howard Johnson's, at the intersection of Blue Hill River Road (on the right in this image) and Route 28. The Howard Johnson's fell victim to the construction of the new Route 128 in 1955. (Courtesy the Randolph Historical Commission.)

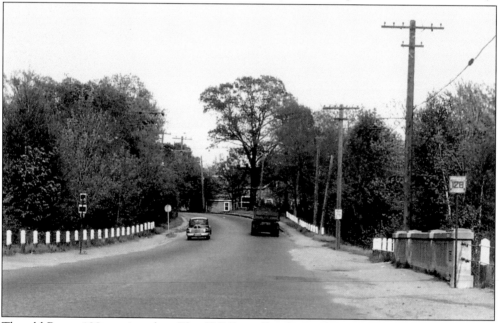

The old Route 128 continued on Blue Hill River Road over the Braintree border, after which it followed portions of West, Franklin, Washington, and Plain Streets before connecting to Grove Street. Here, in May 1947, is an easterly view of Grove Street in Braintree where it crossed the Monatiquot River. Note the old-style rectangular Route 128 sign at the far right. (Courtesy MHD.)

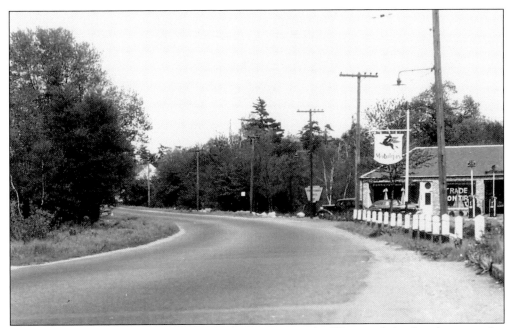

The old Route 128 linked up with Columbian Street at the Weymouth border, shown in this easterly view from 1947. The presence of a service station along what appears to be an otherwise fairly minor rural route is evidence of the impact of the state public works department's Route 128 designation. (Courtesy MHD.)

Farther east along Columbian Street, near the present-day intersection of Park Avenue West, another service station greets motorists in the spring of 1947. Note the recently constructed single-family homes at the left—a common suburban sight in the immediate postwar years. From here, the old Route 128 continued through South Weymouth and Hingham on its way to the final leg of the circumferential journey, Nantasket Avenue in Hull. (Courtesy MHD.)

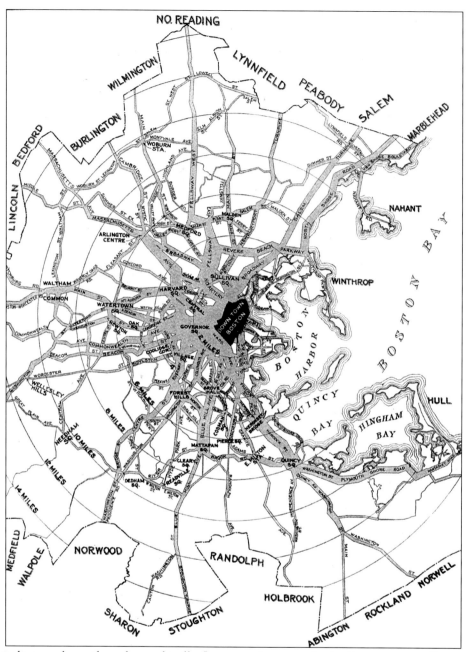

This diagram shows the volume of traffic flow on major routes in the Boston metropolitan area in 1927, including several sections of the old Route 128 north and west of the city. At the time, the makeshift circumferential still handled only light volumes of daily traffic, while the overwhelming majority of the regional travel was focused on a series of radial routes linking Boston with its inner suburbs. These routes not only provided access to the downtown core from outlying areas, but at the time also served as the primary means of traveling from points south of the city to points north. The establishment of the old Route 128 was in part motivated by a desire among Massachusetts Department of Public Works traffic planners to provide a regional bypass of the crowded downtown core.

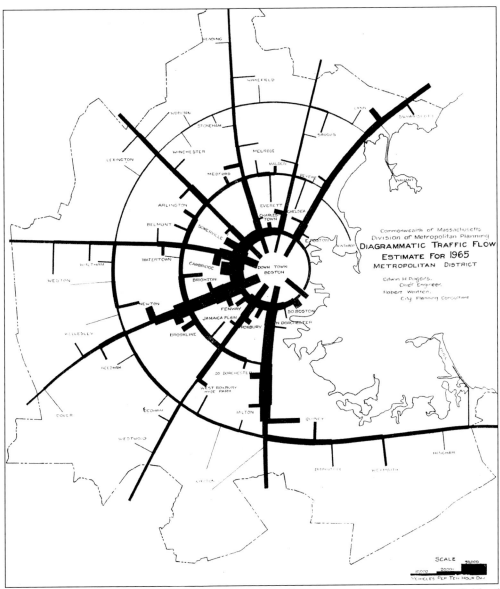

Produced in 1930 by Robert Whitten (a nationally recognized pioneer in the field of transportation planning), this diagram shows the projected flow of traffic in the metropolitan Boston area in 1965. The predicted volume of circumferential traffic along the outer ring (which roughly corresponds to the alignment of most of Route 128) is between 10,000 and 20,000 vehicles per day. These rudimentary estimates would be adopted by the Massachusetts Department of Public Works and the federal Bureau of Public Roads, which assumed a 1970 daily traffic volume of 15,000 vehicles when planning the current Route 128 alignment in the late 1940s. The actual figure approached 100,000.

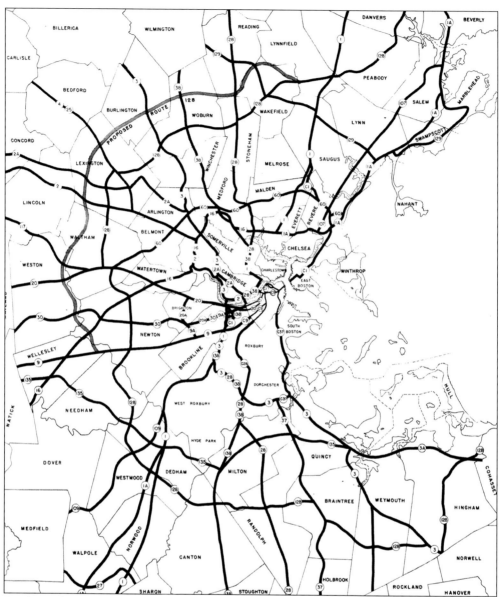

By the mid-1930s, traffic conditions on the old Route 128—especially in the downtowns of Boston's northern and western suburbs—had deteriorated so precipitously that the Massachusetts Department of Public Works began drawing up plans to relocate the highway outside of densely developed areas in these towns. This map, dating from the early postwar years, shows both the old Route 128 alignment and the proposed location of the northwestern arc of the new highway. Although short stretches of the old Route 128 in the vicinity of Route 1 were relocated in the late 1930s and early 1940s (including sections in Peabody and Lynnfield, shown on this map), not until the late 1940s did a powerful confluence of fiscal resources and political leadership make the systematic reconstruction of the old highway a priority.

Two

BUILDING THE NORTHERN ARC
1936–1953

Elected in 1946, Republican governor Robert Bradford made highway planning a priority in his administration. With automobile ownership skyrocketing statewide and a populace eager to move into the suburbs surrounding Boston, the array of constituencies backing the construction of a system of major expressways was formidable. Only a handful of Bradford's plans made it into construction, however, including a short section of Route 128 on the North Shore. (Courtesy the Boston Public Library, Prints Department.)

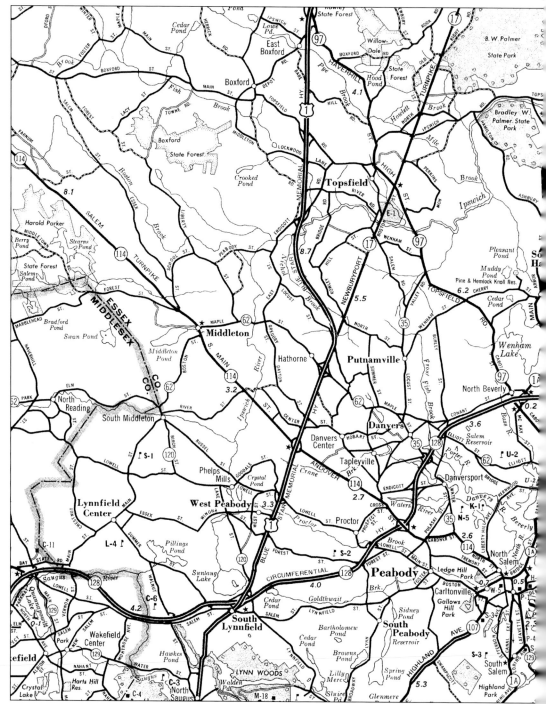

This c. 1955 map shows the alignment of the new Route 128 between its northern terminus at the port city of Gloucester and the Lynnfield-Wakefield border, the southernmost extent of the piecemeal construction of Route 128 in this area between 1936 and 1949. During this time, the

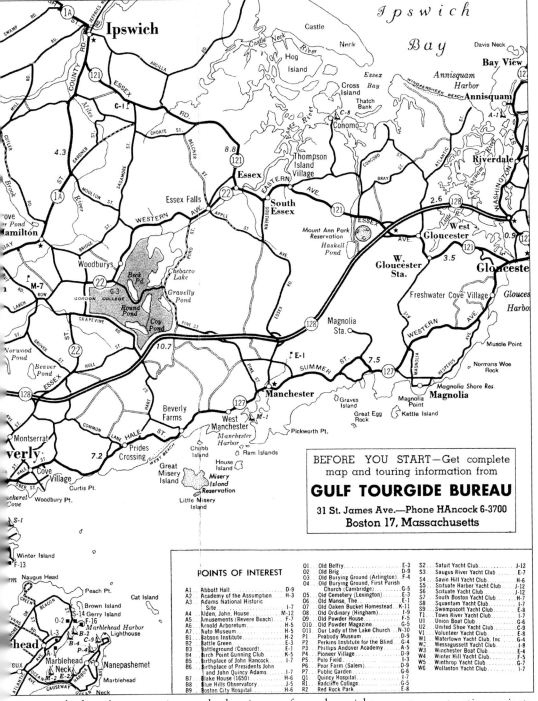

POINTS OF INTEREST

A1	Abbott Hall	D-9
A2	Academy of the Assumption	H-3
A3	Adams National Historic Site	I-7
A4	Alden, John, House	M-12
A5	Amusements (Revere Beach)	F-7
A6	Arnold Arboretum	H-5
A7	Auto Museum	H-5
B1	Babson Institute	H-2
B2	Battle Green	E-3
B3	Battleground (Concord)	E-1
B4	Birch Point Gunning Club	K-5
B5	Birthplace of John Hancock	I-7
B6	Birthplace of Presidents John and John Quincy Adams	I-7
B7	Blake House (1650)	H-6
B8	Blue Hills Observatory	J-5
B9	Boston City Hospital	H-6

O1	Old Belfry	E-3
O2	Old Brig	D-9
O3	Old Burying Ground (Arlington)	F-4
O4	Old Burying Ground, First Parish Church (Cambridge)	G-5
O5	Old Cemetery (Lexington)	E-3
O6	Old Manse, The	E-1
O7	Old Oaken Bucket Homestead	K-11
O8	Old Ordinary (Hingham)	I-9
O9	Old Powder House	F-5
O10	Old Powder Magazine	G-5
O11	Our Lady of the Lake Church	N-10
P1	Peabody Museum	D-9
P2	Perkins Institute for the Blind	G-4
P3	Phillips Andover Academy	A-5
P4	Pioneer Village	D-9
P5	Polo Field	I-3
P6	Poor Farm (Salem)	D-9
P7	Public Garden	G-6
Q1	Quincy Hospital	I-7
R1	Radcliffe College	G-5
R2	Red Rock Park	E-8

S2	Satuit Yacht Club	J-12
S3	Saugus River Yacht Club	E-7
S4	Savin Hill Yacht Club	H-6
S5	Scituate Harbor Yacht Club	J-12
S6	Scituate Yacht Club	J-12
S7	South Boston Yacht Club	H-7
S8	Squantum Yacht Club	I-7
S9	Swampscott Yacht Club	E-8
T1	Town River Yacht Club	I-7
U1	Union Boat Club	G-6
U2	United Shoe Yacht Club	C-9
V1	Volunteer Yacht Club	E-8
W1	Watertown Yacht Club, Inc.	G-4
W2	Wessagussett Yacht Club	I-8
W3	Winchester Boat Club	E-4
W4	Winter Hill Yacht Club	F-5
W5	Winthrop Yacht Club	G-7
W6	Wollaston Yacht Club	I-7

new highway's construction was broken into no fewer than eight separate construction projects,
averaging less than two miles each. A critical eight-mile stretch between Beverly and Gloucester
was not completed until 1953.

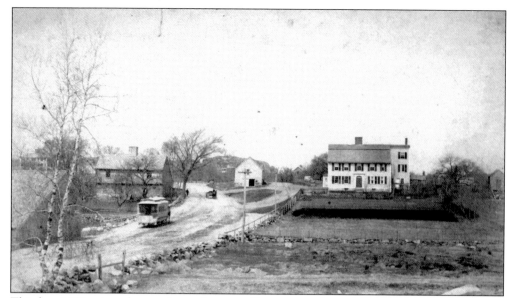

This late-1800s view shows a horse-drawn trolley passing the *c.* 1650 White-Ellery home (to the left of the roadway) in the city of Gloucester near the present-day Route 128 rotary at Washington Street. (Courtesy the Cape Ann Historical Society.)

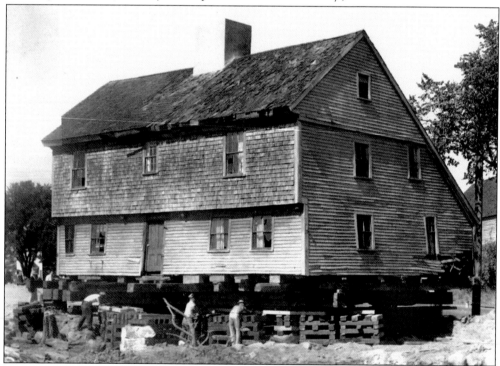

Looking somewhat worse for the wear here in the summer of 1947, the White-Ellery home is being jacked up in preparation for being moved out of the new highway's path. Although the house was originally slated for demolition by the Massachusetts Department of Public Works, a private fund was established to save the home by moving it to its present location on Washington Street, just off Grant Circle. (Courtesy the Cape Ann Historical Society.)

The first portion of the new Route 128 to be constructed in the city of Gloucester was a short stretch east of Essex Avenue that included the approaches to the Annisquam River Bridge. This remarkably well appointed structure, constructed in 1949 by DeMatteo Construction, carries the new Route 128 over Essex Avenue. (Courtesy MHD.)

This view shows the bridge carrying Crafts Road over the new 128 just west of the Annisquam River Bridge in Gloucester, whose approach is clearly visible in the background. Although the Annisquam River crossing's approaches—including the overpass pictured here—were completed in the fall of 1949 by DeMatteo, the finished sections of Route 128 on either side of the river stood idle for nearly two years until the crossing itself was completed. (Courtesy MHD.)

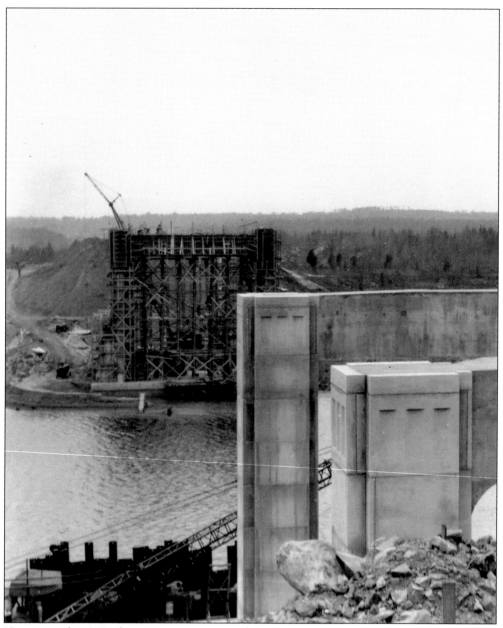

Here, in early 1949, the western main pier of the Annisquam River Bridge in Gloucester is being formed in the distance while excavation for the foundation of the eastern main pier proceeds in the lower left corner. The Coleman Brothers Corporation, one of the area's largest heavy civil contractors at the time, won the job of building the piers and their foundations in July 1948. The price: $1.013 million. (Courtesy MHD.)

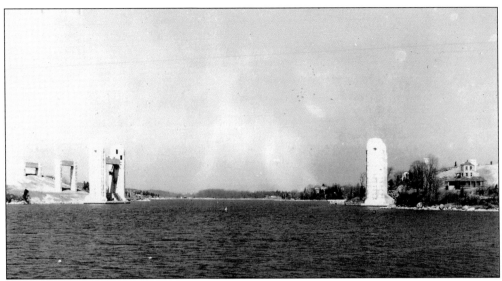

This view looks north in the spring of 1950 past the completed piers of the Annisquam River Bridge. Coleman Brothers began work on the piers in the fall of 1948 with a projected completion date of July 1949. Coleman experienced severe delays while constructing foundations early in the project because of unforeseen subsurface conditions, and the piers were not completed until early 1950. (Courtesy MSA.)

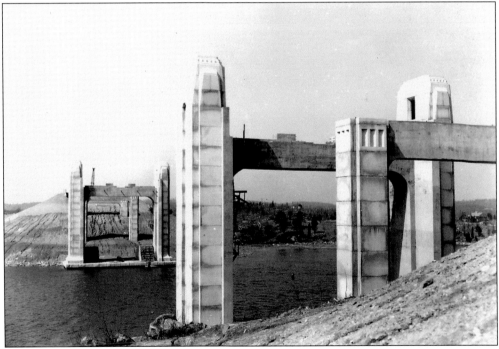

The completed piers of the Annisquam River Bridge stand ready to receive the steel bridge structure in early April 1950. Of note are the decorative details cut into the granite facing at the tops of the piers. Despite the added expense of such details, at the time Route 128 was built, large public works projects were still often treated by designers and planners as public monuments whose visual characteristics were an integral part of the design. (Courtesy MSA.)

35

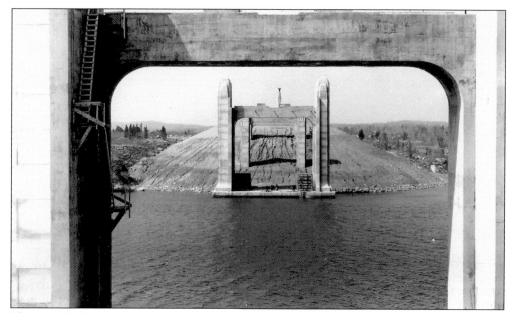

This view looks west under one of the completed piers of the Annisquam River Bridge in April 1950. The piers, constructed of concrete, were faced with thin-sawed slabs of local granite. Clearly visible in this view is the massive mound of fill piled on the western shore of the river in order to bring the approach roads up to grade and shorten the clear span of the bridge. (Courtesy MSA.)

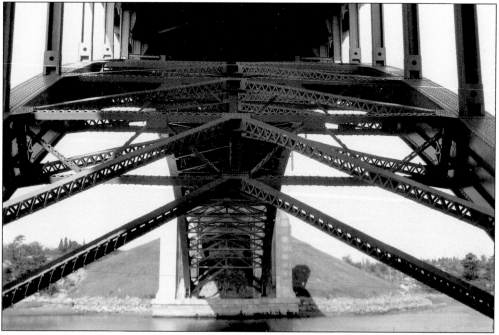

A similar view from August 1951 shows the intricate trusswork that forms the backbone of the Annisquam River Bridge. The roadway deck assembly is supported on columns that rest on the two large steel arches spanning the river itself. The arches are held firmly in place by the smaller diagonal bracing prominent in the foreground. (Courtesy MSA.)

This image shows the intricate matrix of reinforcing steel designed to stiffen the concrete face of the bridge's bearing blocks, on which much of its load would ultimately rest. Once the final layer of concrete has been placed, the long steel dowels will remain protruding from the block's face and will fit through holes in the steel base plate of the bridge's main arch, anchoring it in place. (Courtesy MSA.)

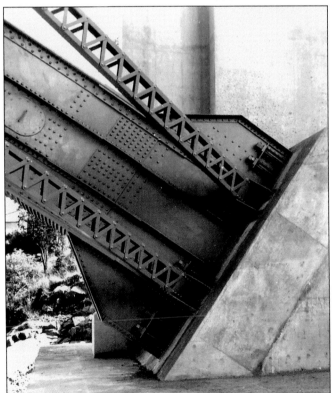

Pictured here is one of the completed bridge's massive bearing blocks, located in pairs at the base of the main piers on each side of the river. The bridge's main steel arches came to rest on these blocks, which transferred the load to deep foundations. (Courtesy MSA.)

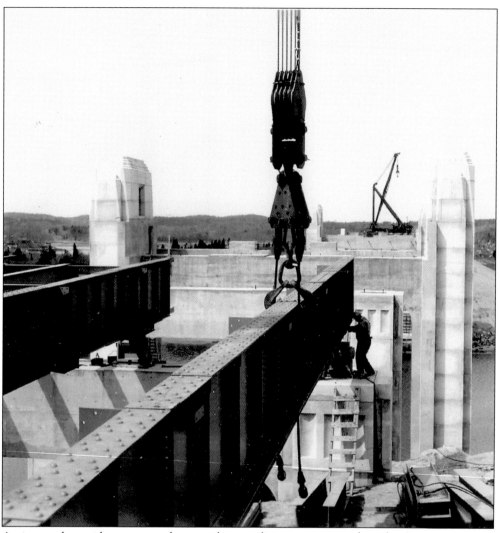

An ironworker guides a main girder into place on the eastern approach to the Annisquam River Bridge in the spring of 1950. These girders were too massive to be lifted by conventional mobile cranes, so the Bethlehem Steel Company, one of the nation's largest steel fabricators and erectors at the time, installed two fixed derricks similar to those traditionally used in quarrying operations at each end of the bridge to do the job. (Courtesy MSA.)

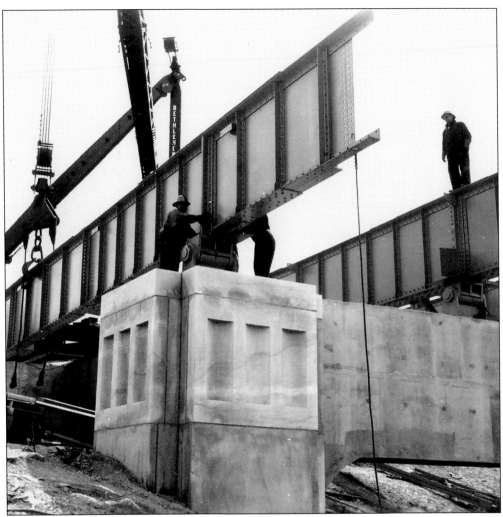

In this dramatic view, workers ease one of the main girders of approaches to the Annisquam River Bridge into place in April 1950. In the days before field welding of structural steel became a widespread practice, these girders had to be fastened to other structural elements of the bridge with hundreds of rivets (each heated red-hot in the field). The predrilled holes for the rivets are evident at the end of the girder's web. (Courtesy MSA.)

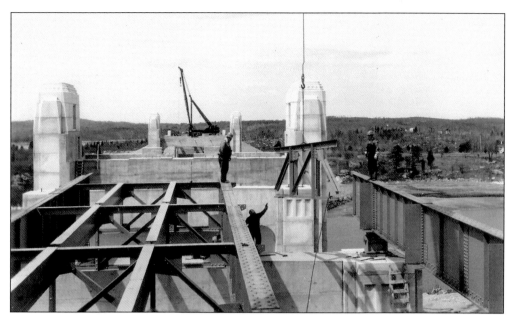

Ironworkers stand by as one of the bridge's lateral braces is lowered into place high above the Annisquam River. Despite their precarious perch atop the bridge's main girders, the workers are not wearing safety harnesses. Adding to the hazard, the crane operator was unable to directly observe the position of the load and relied entirely on the hand signals of a spotter to guide the dangling half-ton brace. (Courtesy MSA.)

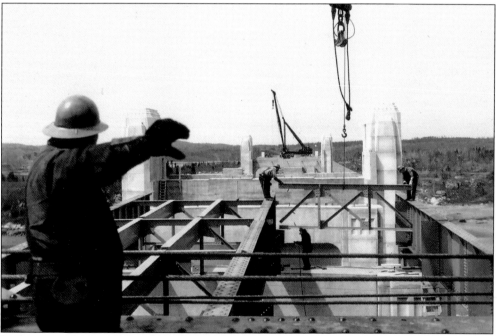

In this view, the spotter signals to the crane operator as the lateral brace is guided carefully into place. The braces such as the one being installed here serve a dual function. They prevent the bridge's main girders from rocking side to side on their pedestals and also provide support for smaller girders (visible at the left) that support part of the roadway deck itself. (Courtesy MSA.)

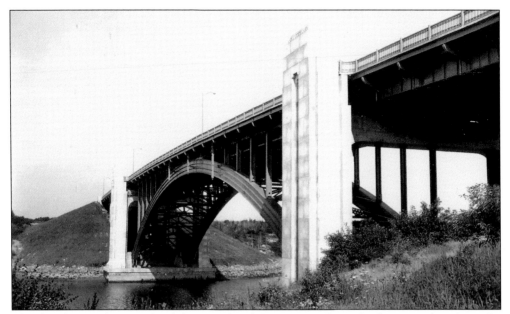

This handsome photograph of the completed Annisquam River Bridge was taken from the river's eastern bank in August 1951. By an act of the legislature in the summer of 1949, the bridge was named after Abram Piatt Andrew, who served as Gloucester's congressman from 1921 until his death in 1936. The job of carving Andrew's name into the bridge piers was one of just two extra work items on the entire bridge job, costing $335. (Courtesy MSA.)

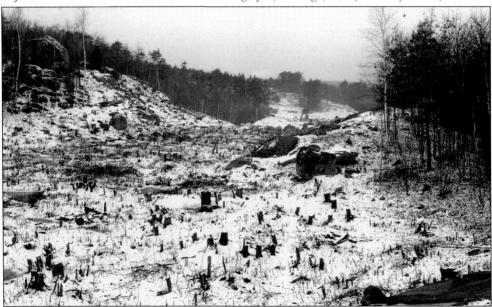

In early 1952, the Massachusetts Department of Public Works began pushing the new Route 128 west from its existing terminus at Essex Avenue. This view gives a good survey of the difficult terrain through which this section of the highway had to be constructed. Here, high granite hills alternate with swampy valleys in the vicinity of Haskell Pond. John McCloskey, assistant to commissioner William Callahan, called this eight-mile stretch of work "the toughest piece of road construction ever undertaken in eastern Massachusetts." (Courtesy MSA.)

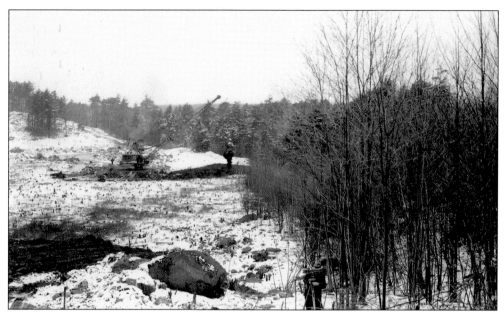

Here, in western Gloucester in December 1952, a distant crane dredges soft peat out of Cedar Swamp as the highway pushes westward to link up with the already completed stretch between Beverly and Wellesley. In order to provide stable bearing material for the road in this area, over 500,000 cubic yards of peat and other unsuitable substrate had to be removed and replaced with gravelly fill at great expense. (Courtesy MSA.)

Taken in the winter of 1952, this photograph shows workers from the Gil Wyner Company preparing to begin the rough grading of the new highway after clearing the forest cover in western Gloucester. To the lower right are the air compressors that power the pneumatic drills of the blasting crews. Despite the frozen ground, earthwork on this section of the new Route 128 continued through the winter of 1952. (Courtesy MSA.)

Pictured just before Christmas of 1952, Wyner Company workers use pneumatic drills to prepare a rock ledge in Gloucester for blasting. Although tedious and expensive, blasting through the rocky hills in undeveloped areas in many of Boston's suburbs proved more cost-effective than routing the new highway through topographically milder but more densely developed areas in these towns. (Courtesy MSA.)

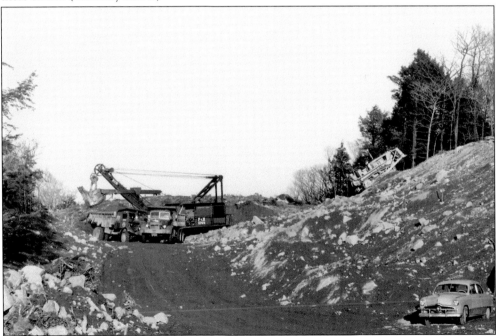

In this view from the fall of 1952 at the Gloucester-Manchester border, the right-of-way for the "missing link" between Gloucester and Beverly has been cleared of trees and brush, and bulk excavation is proceeding in order to expose the rocky ledge that will need to be blasted away to make way for the new highway through the rough North Shore terrain. (Courtesy MHD.)

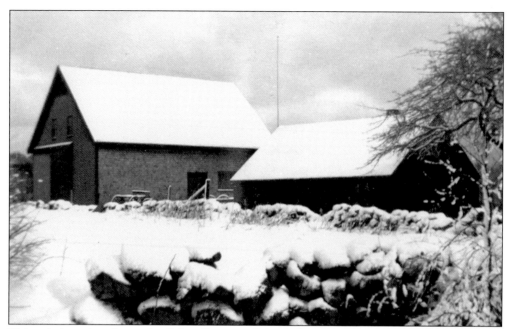

This pristine view shows the Baker Farm on School Street in the small seaside community of Manchester prior to the start of construction on the new highway between Beverly and Gloucester in early 1952. (Courtesy the Manchester Historical Society.)

The Baker Farm is shown in the summer of 1953 as the School Street interchange nears completion. Unlike many other nearby towns, the coming of Route 128 changed little in Manchester, and this stretch of Route 128 remains one of the least developed anywhere along the roadway's 65-mile length. (Courtesy the Manchester Historical Society.)

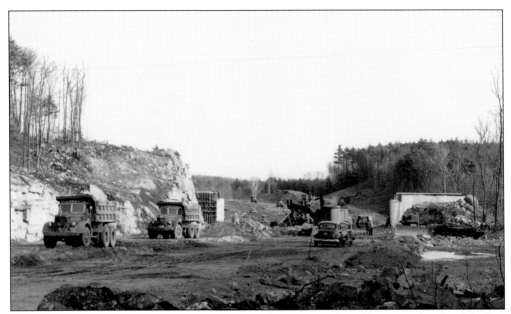

This view looks east near School Street in Manchester in early 1953 over a stretch of the last section of new Route 128 to be completed on the North Shore, begun in the spring of 1952 and completed in the fall of 1953 between Essex Street (Route 22) in Beverly and Essex Avenue (Route 133) in Gloucester. The concrete abutments of the future School Street overpass are visible in the center of the image. (Courtesy MHD.)

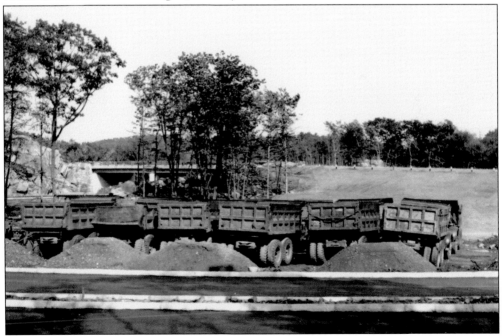

A row of dump trucks deposits fill for the finish grading of the School Street interchange in the summer of 1953. The completed School Street overpass is visible to the left, and the freshly curbed and paved interchange ramps are in the foreground. (Courtesy the Manchester Historical Society.)

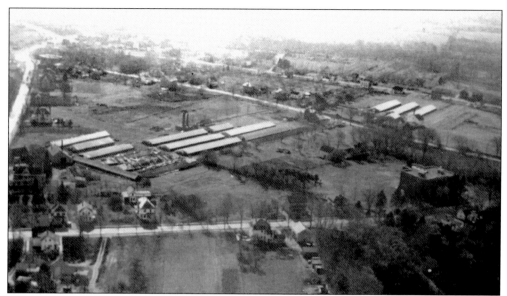

This 1945 southerly view over the town of Beverly shows the triangle of local roads through which the new Route 128 would pass. At the far left is Dodge Street. Conant Street is in the foreground, and Cabot Street is in the distance. Although construction of the new Route 128 began in this area as early as the spring of 1946, state highway funds were so limited that only a three-quarter-mile stretch of the road could be built. (Courtesy the Beverly Historical Society.)

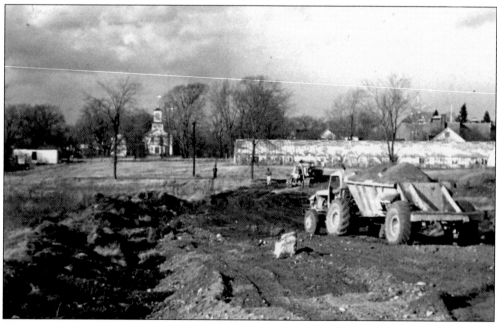

This view looks north toward Conant Street in the spring of 1946, with the greenhouses of Caldwell Farms (clearly visible in the previous image) to the right and the spire of the Second Church in the distance. Also shown is a bottom dump bringing the new highway's right-of-way up to grade in order to carry it over Cabot and Dodge Streets. (Courtesy the Beverly Historical Society.)

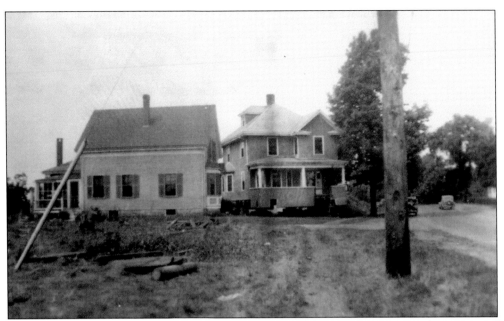

The home of Harry Woodbury is shown here being moved down Cabot Street in the summer of 1946 across his neighbor Lewis Symmes's front yard and out of the new highway's right-of-way. (Courtesy the Beverly Historical Society.)

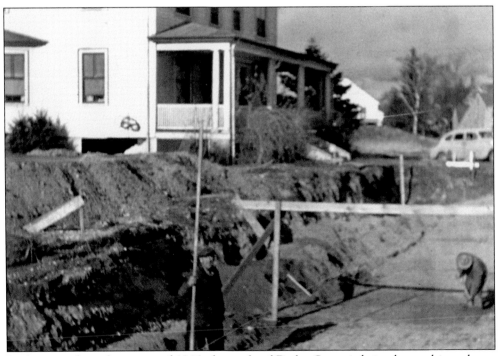

In this view from the winter of 1946, the grade of Dodge Street is being lowered in order to minimize the incline on the new highway's overpass approaches and interchange ramps. The white house in the foreground was demolished to make way for the interchange. (Courtesy the Beverly Historical Society.)

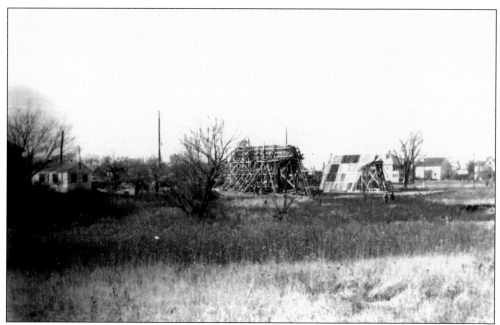

The construction of the Cabot Street overpass is visible in this view taken in the winter of 1946 from Ludden's Meadow, just south of the new highway. To the far left is the field office of DeMatteo Construction, which built many sections of Route 128 on the North Shore in the late 1940s. (Courtesy the Beverly Historical Society.)

In this northwesterly view from February 1947, formwork for one of the Cabot Street overpass abutments is to the left, and homes along Cabot Street are visible in the center. To the right is the winterized shed that serves as a sawmill for the wooden formwork. (Courtesy the Beverly Historical Society.)

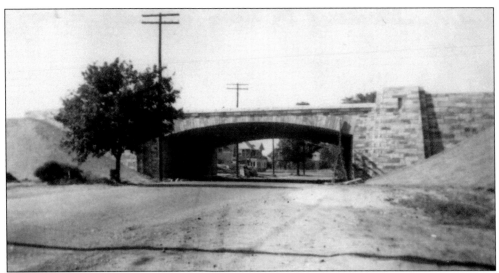

The Cabot Street overpass nears completion in the fall of 1947. The 55-foot span was cast out of concrete and then faced with granite taken from several different quarries in order to achieve an aesthetically pleasing variety of colors and textures. Curiously, bridges in this area were also constructed with an ample sidewalk on each side of the roadway, even though the rest of the highway was not. (Courtesy the Beverly Historical Society.)

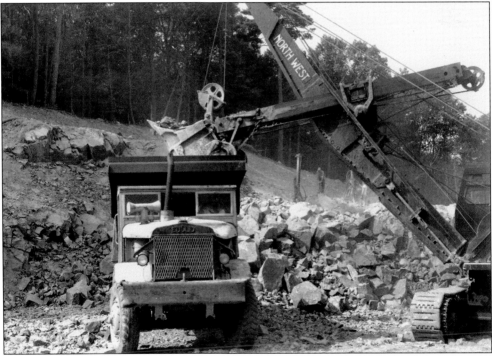

Work on short sections of the new Route 128 in Beverly proceeded piecemeal through 1949 but ceased until 1952, when work on the last eight-mile section of the new highway between Beverly and Gloucester began. In this image from the summer of 1952, as drilling crews continue work in the background, an archaic-looking power shovel loads debris into a waiting dump truck in the Beverly hills. (Courtesy MHD.)

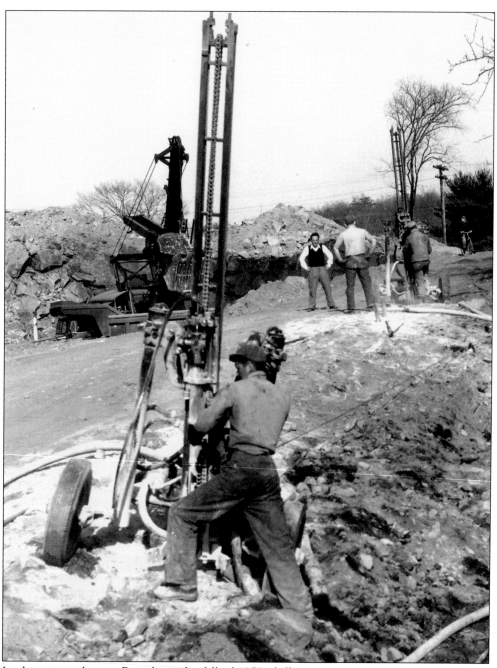

In this view, taken in Beverly in the fall of 1952, drilling crews prepare a ledge for blasting while debris from a previous round of blasting is excavated in the background. The extent of the blasting work required to construct this last stretch of new Route 128 in Beverly and Gloucester made it one of the most expensive per-mile highway-construction jobs in the history of the Commonwealth. (Courtesy MHD.)

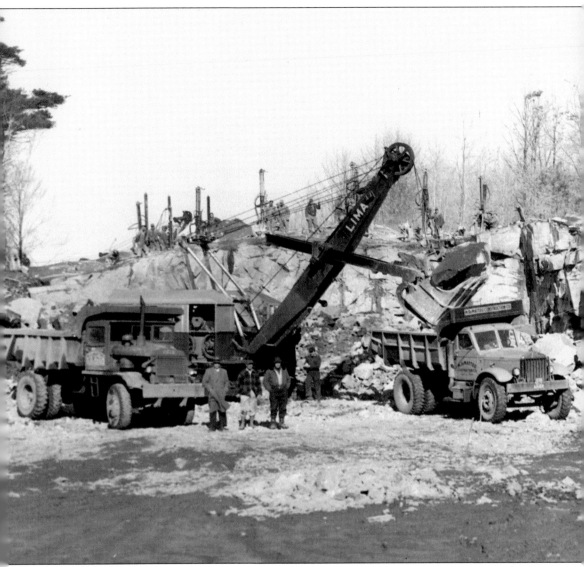

Work crews from DeMatteo Construction pose in front of a major cut through the rocky hills of Beverly. Atop the ledge, the dense North Shore conifer forest has been cleared and replaced by a forest of drill rigs preparing the rock for blasting. DeMatteo, based in Quincy, was one of the area's largest heavy-construction contractors at the time. In addition to building much of Route 128 on the North Shore, DeMatteo constructed major portions of Logan Airport, the Southeast Expressway, and the Massachusetts Turnpike. (Courtesy DeMatteo Construction.)

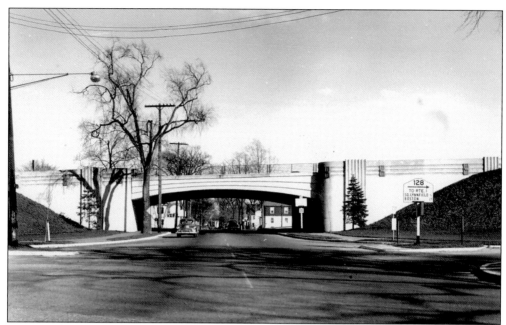

A three-mile stretch of the new highway in Danvers was constructed in 1941 just before the outbreak of World War II, and the few bridges built as part of that project were remarkable examples of monumental Art Deco architecture. This southeasterly view shows the handsome structure that carries the new highway over High Street in Danvers. (Courtesy MHD.)

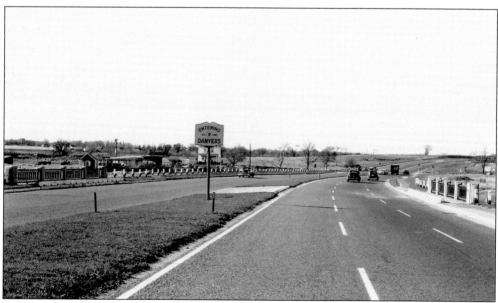

This view shows the stretch of new highway constructed in 1941 in Danvers at the Peabody border. The bridge structure visible in the foreground carries the highway over the Waters River, which was relocated (along with the borderline between Peabody and Danvers) as part of the construction. By 1955, the Endicott Street overpass and interchange, serving the Liberty Tree Mall and Endicott Plaza, would be completed just north of this point. (Courtesy MHD.)

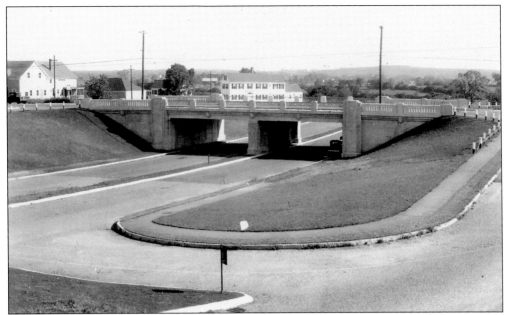

Pictured in September 1939 is the curious interchange between the new Route 128 and Andover Street (Route 114) in Peabody, constructed in 1938. Of note are the lozenge-shaped access ramps, the exceedingly tight ramp curves, and the lack of a merging lane. A modern-day drive through Peabody and neighboring Danvers provides an excellent illustration of the evolution of highway and interchange design standards from the late 1930s to the interstate highway era. (Courtesy MHD.)

The first portion of the new Route 128 to be constructed began here in Lynnfield in 1936 and was intended to provide a direct connection between Route 1 (at the time referred to as the Newburyport Turnpike) and the recreational amenities of the Cape Ann communities. This early-1936 view shows homes along Route 1 that would be taken for the interchange with the new Route 128. (Courtesy Warren Falls.)

Route 1 in Lynnfield is pictured in July 1936 prior to the start of construction. To the right is the Moxam house, the home of the Lynnfield fire chief. At the time this photograph was taken, the Newburyport Turnpike was one of the Commonwealth's two major modern expressways (the Worcester Turnpike, or Route 9, was the other) and was studded with grade crossings and traffic signals. (Courtesy Warren Falls.)

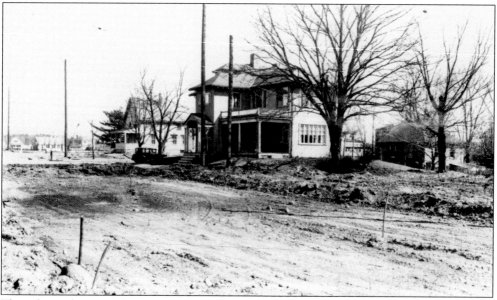

This identical view, taken in the early spring of 1937, shows the widening and regrading of Route 1 that accompanied the interchange construction in front of the Moxam home. Although it survived the first round of Route 128 construction, the home would fall victim to the highway's widening in 1959. (Courtesy Warren Falls.)

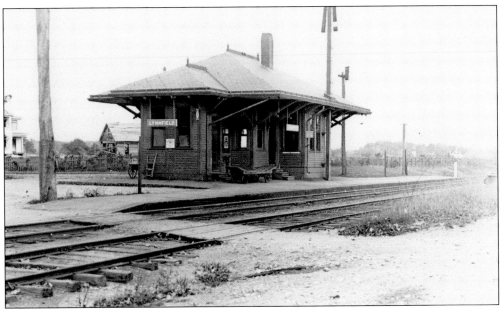

This 1918 view shows the Lynnfield station of the Boston and Maine Railroad's South Reading line at the point where the Newburyport Turnpike would be constructed in 1934, followed two years later by the interchange with Route 128. The line was an instant success when it opened in the summer of 1850, but by the mid-1920s, passenger and freight traffic on the line (which fed North Station in Boston) had fallen off dramatically. (Courtesy Warren Falls.)

In 1926, the Boston and Maine abandoned the South Reading branch and replaced its passenger service with a motor bus line that served downtown Boston. The conversion was an omen of things to come. Here, in the summer of 1936, is a northerly view of the Newburyport Turnpike at the future location of the Route 128 interchange. The old Lynnfield station is to the far right. (Courtesy Warren Falls.)

This view looks northeast along the abandoned Boston and Maine corridor at the Peabody border in July 1936. Massachusetts Department of Public Works commissioner William Callahan took a portion of the abandoned rail bed as a ready-made alignment for the new Route 128, one of his first major highway projects. He would use the same strategy on his last highway project a quarter-century later, when he brought the Massachusetts Turnpike into Boston by widening the old Boston and Albany main-line corridor. (Courtesy Warren Falls.)

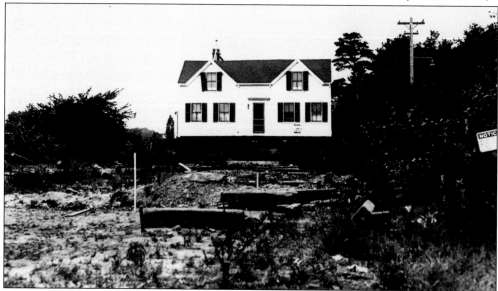

This curious view shows a home being moved across the old rail bed in South Lynnfield and out of the way of the new interchange's construction in the fall of 1936. At the time, the practice of moving homes and other structures out of the way of public works projects was common, even in dense urban areas. (Courtesy Warren Falls.)

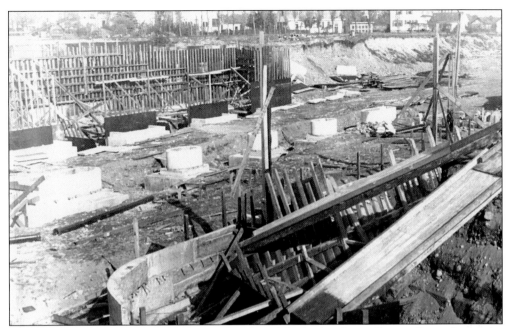

Shown in October 1936 is the early construction of the bridge that will carry Route 1 over the new Route 128. The bases of the bridge's central piers are visible in the median strip of the future double-barreled highway, and wooden formwork for the bridge's abutments flanks the path of the new highway. (Courtesy Warren Falls.)

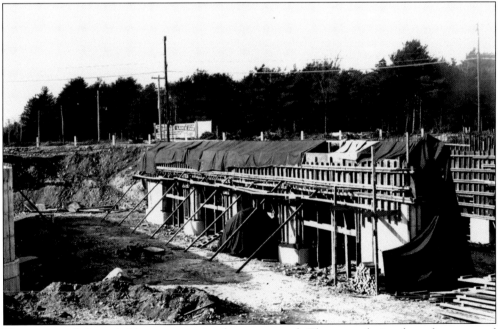

Here, a month later, bridge construction has progressed. The central piers have been poured and are curing under layers of blankets that keep the wet concrete from freezing in the winter cold. On the far side of Route 1 in the distance, a billboard advertises the Suntaug Lake Inn, a popular nearby restaurant and dance hall. (Courtesy Warren Falls.)

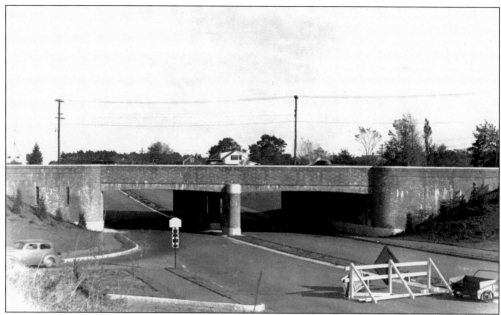

By the fall of 1938, the Route 1 interchange has been completed and the new stretch of highway is in operation. The remarkable stone and brick facade of the new overpass is clearly visible in this easterly view. (Courtesy Warren Falls.)

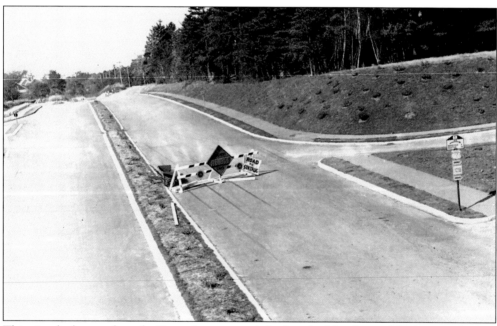

This view looks west from the Route 1 overpass. A few hundred feet beyond the barrier, the new highway petered out into a field just south of Suntaug Lake. In an era when highway funding was often diverted to other programs, construction progressed just a few miles at a time. Note the sign directing motorists to rejoin the old Route 128 (Salem Street) just south on Route 1. (Courtesy Warren Falls.)

Taken just east of the new interchange, this photograph clearly shows the sharp dip the new highway takes under Route 1. This scene was dramatically altered in the fall of 1959, when construction began on the widening of the highway and a new Route 1 interchange just over the Peabody border. The brown house to the left was moved to Danvers to avoid demolition. (Courtesy Warren Falls.)

This easterly view of the new highway from Route 1 shows evidence of one of the Commonwealth's most curious depression-era make-work programs. To the right, concrete sidewalks are clearly visible alongside the roadway, even though pedestrians were officially barred from limited-access highways like Route 128. The construction of sidewalks along state highways allowed William Callahan to put thousands of unemployed to work (and expand his political power base) during the depths of the depression. (Courtesy Warren Falls.)

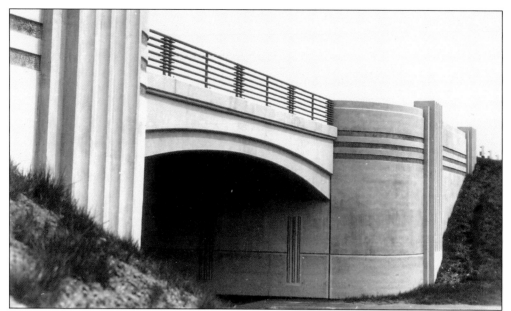

The initial stretch of the new Route 128 was extended about two miles west of the Route 1 interchange beginning in 1940. This striking view of the Route 128 bridge over Summer Street in Lynnfield shows the attention to detail that characterized the few concrete bridges constructed along this stretch of the highway before the outbreak of World War II brought a halt to all road construction in the Commonwealth. (Courtesy MHD.)

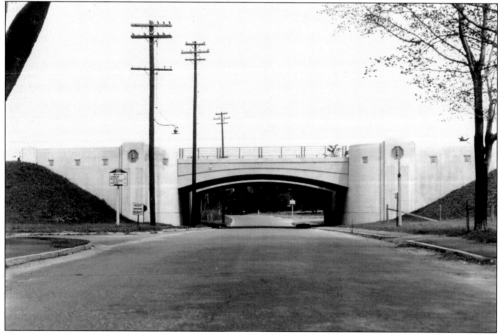

Pictured in the spring of 1948 is the sleek Art Deco bridge that carries Route 128 over Walnut Street in Lynnfield. This was one of just a handful of such structures constructed between 1940 and 1941 on a short stretch of the new highway in southern Lynnfield between the Newburyport Turnpike (Route 1) and Walnut Street. (Courtesy MHD.)

Three

BUILDING THE WESTERN ARC
1950–1951

Reappointed to his old post of commissioner of the Massachusetts Department of Public Works by incoming governor Paul Dever in 1949, William Callahan, pictured here in 1949, made the construction of the new Route 128 and the Central Artery in downtown Boston his top priorities under the Commonwealth's new $100 million highway program. (Courtesy the Boston Public Library, Prints Department.)

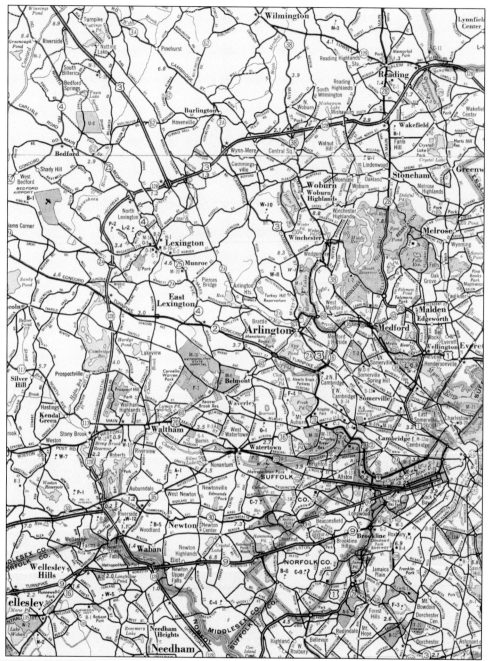

This c. 1957 map shows the alignment of the section of the new Route 128 from the Lynnfield-Wakefield border to the Wellesley-Needham border, constructed between the spring of 1950 and the summer of 1951 under the direction of Massachusetts Department of Public Works commissioner William Callahan and his staff. The primary design intent of the new highway—bypassing the town centers that created such arduous travel conditions on the old Route 128—is clear, as the new highway passes through areas that at the time of its design and construction were sparsely populated. Note that the Massachusetts Turnpike, completed in 1957, reaches its eastern terminus at Route 128. It would not continue into downtown Boston for another five years.

62

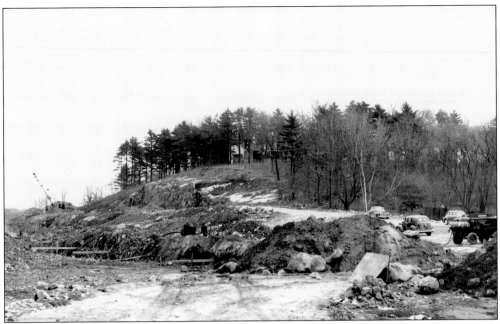

Construction of the new Route 128 from Wellesley to Wakefield started almost simultaneously in the spring of 1950 all along its 22-mile length. This November 1950 view surveys the scene on the Reading-Wakefield border as the highway is being carved out of the existing topography just east of Hopkins Street. (Courtesy MHD.)

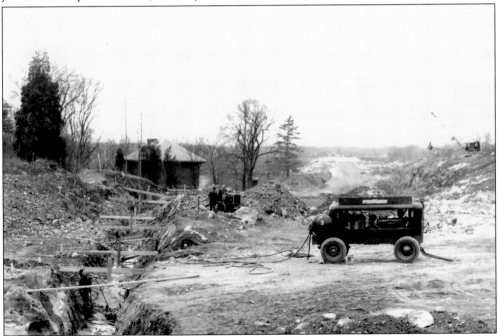

This view looks northeast at the same location and shows a trench that will carry a drainage conduit to the small Metropolitan District Commission pumping station in the background. The pumping station still stands today, despite being peppered with blasted rock during a poorly executed blasting job in September 1950. (Courtesy MHD.)

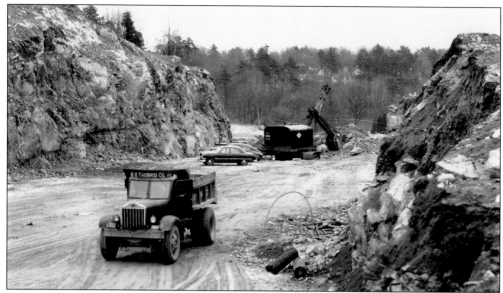

Pictured in the fall of 1950 is a major cut through a rocky hill near Brook Street in Wakefield. The right-of-way can be seen curving off to the north in the distance as the highway bypasses Lake Quannapowitt. Although arcing the new highway's alignment north of the lake meant a longer route, the more direct path south of the lake would have required substantial property takings and was calculated by department of public works right-of-way engineers to be more expensive. (Courtesy MHD.)

Here is the completed Route 128 near Brook Street in Wakefield in the summer of 1952, along the section of new highway that William Callahan called "the most picturesque part . . . through solid ledge like up in the mountains." Brook Street residents took a less appreciative view of the road after their homes were showered with rock fragments from the same botched blasting job that nearly brought down the Metropolitan District Commission pump station in September 1950. (Courtesy MSA.)

From Wakefield, the new Route 128 would pass into Reading at an interchange with Route 28 (Main Street), shown in this late-1940s northeasterly view. In the foreground is King's Vegetable Stand, which was leveled to make way for the new interchange. The Englund family farmhouse, just visible to the left, was moved nearby to avoid a similar fate. (Courtesy Mary Englund.)

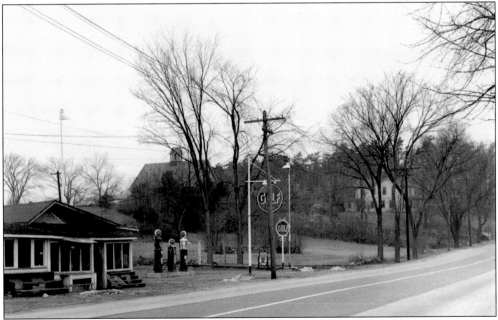

This view looks northwest from in front of King's Vegetable Stand toward Eleanor and Stan Brown's farm stand and filling station and the Englund family's barn. Although the barn survived the construction and widening of Route 128, the Englund family sold the farm to Addison Wesley for the site of their world headquarters in the early 1960s. (Courtesy the Reading Historical Commission.)

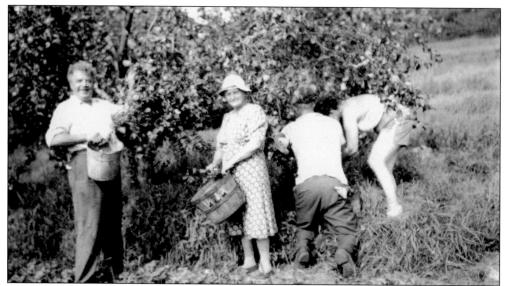

In this view, Englund family patriarch Carl and matriarch Ida are harvesting apples on the Reading farm, one of many in Boston's northern suburbs that remained active in the immediate postwar years. Farmland like that of the Englunds made an inexpensive right-of-way for the Commonwealth's highways, however, and provided attractive sites for the commercial development that followed. (Courtesy Rick Englund.)

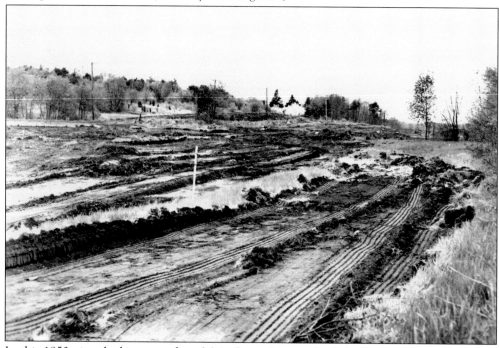

In this 1950 view, looking west from Main Street just south of the Englund farm, the Brown family's filling station has fallen victim to the new highway. In flat areas like this, construction of the new highway was fairly simple and involved rough grading (shown here), stripping the topsoil, and replacing it with a bed of course gravel that would form the substrate for two thick layers of asphalt paving. (Courtesy Mary Englund.)

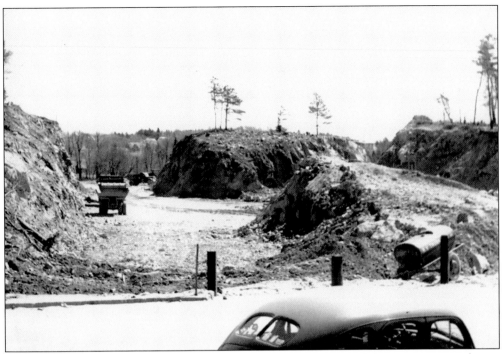

This view, taken in the early spring of 1951, shows the construction of the Route 28 interchange through a rocky outcropping in Reading once blasting has been completed. Even amid the heavy construction, Main Street had to remain open to traffic, as it served as a major regional north-south thoroughfare prior to the completion of Interstate 93 through this area in 1960. (Courtesy the Reading Historical Commission.)

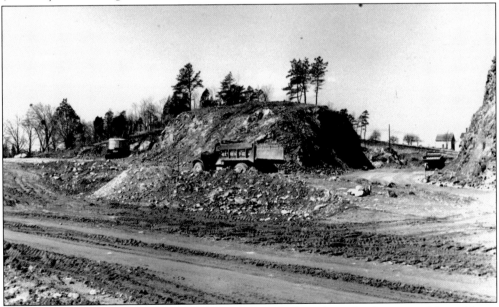

Here is the converse view of the same interchange, looking from the future northbound lanes of Route 128 up the nascent ramp that will provide access to Route 28 southbound. (Courtesy the Reading Historical Commission.)

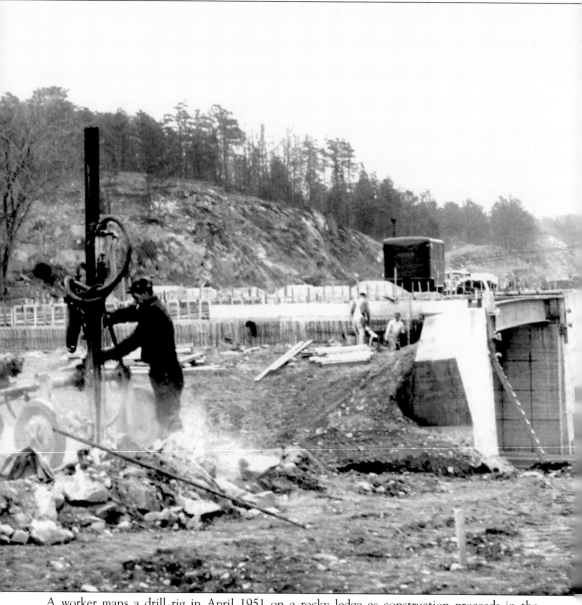

A worker mans a drill rig in April 1951 on a rocky ledge as construction proceeds in the background on the overpass that will carry the new highway over Route 28. Once the drilling crews had completed their work, dynamite crews filled the holes with a carefully determined number of foot-long dynamite rods and blasting cord and then tamped them down with a covering of earth. Often, the primed holes were left overnight, and Reading police officers enjoyed overtime duty guarding the explosives. (Courtesy MHD.)

This preconstruction view looks north along Route 28 just south of the future interchange with the new highway in Reading, with the Monat Gardens shop to the right. The old Route 128 ran directly through Stoneham's heavily congested downtown, just over a mile south of this location. Fred Schneider, then chairman of the Stoneham Board of Selectmen, was a strong proponent of the new highway's construction. (Courtesy MSA.)

Here is the same view just over two years later. In the background, the road has been widened to accommodate ramp traffic, and Monat Gardens is now the site of an office park. One businessman in downtown Stoneham expressed concern in 1949 that the relocation of Route 128 out of the town center would "make Stoneham a ghost-town." (Courtesy MSA.)

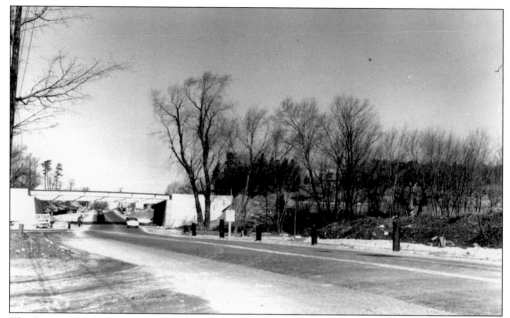

The Route 128 bridge over Main Street is taking shape near the Reading-Stoneham border in the late winter of 1951. The concrete abutments have been completed, and the bridge's main girders have been placed and await the construction of the concrete and asphalt roadway deck. (Courtesy the Reading Historical Commission.)

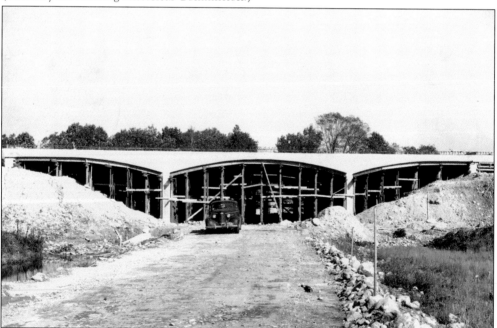

This interesting photograph from October 1950 shows temporary formwork supporting the recently poured arched concrete haunches of the structure that will carry the new highway over Walnut Street in the southeastern corner of Reading. Walnut Street once connected to Cedar Street in Stoneham but was dead-ended by the construction of the Interstate 93 interchange in this area less than a decade after this picture was taken. (Courtesy MHD.)

Pictured is a view looking north up Washington Street in Woburn at the location of the future interchange with Route 128. Although traditionally home to many industrial facilities, parts of Woburn retained the rural character illustrated in this view until the construction of Route 128. Today, this area is a nexus of commercial activity, hosting a series of major office developments and a regional shopping center. (Courtesy MHD.)

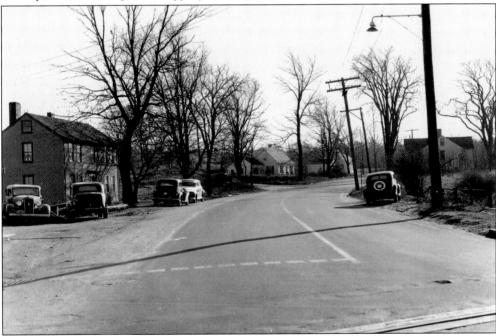

This 1949 view in Woburn looks south from the point where the Woburn Loop of the Boston and Maine Railroad's Boston and Lowell line crosses Main Street (Route 38) at grade just north of the future Route 128 interchange. All of the houses in this view were demolished to make way for the interchange. (Courtesy MSA.)

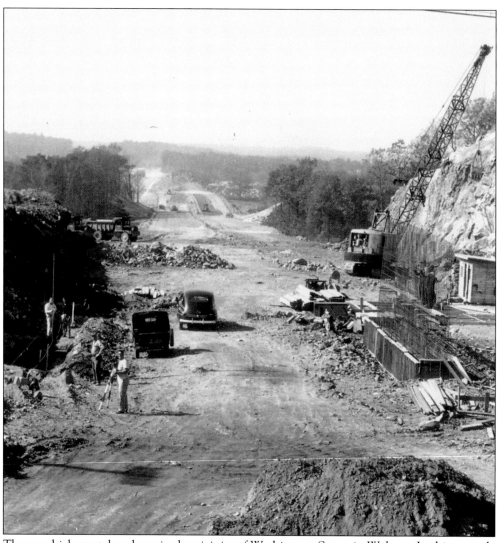

The new highway takes shape in the vicinity of Washington Street in Woburn. In this westerly view from the fall of 1950, the concrete piers and abutments of the Washington Street overpass are being formed and reinforced in the foreground, while debris from a recent blasting job are being cleared in the background. (Courtesy MHD.)

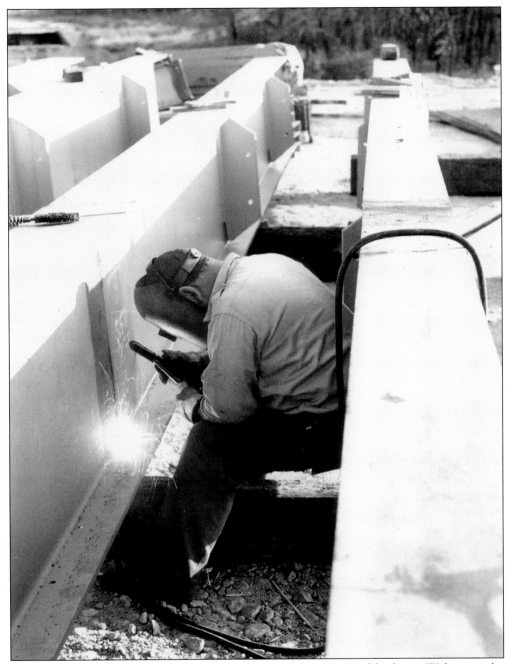

A welder tends to a detail on a steel beam for the Mishawum Road bridge in Woburn in the fall of 1950. Although the practice of field welding was still in its early years in 1950, it had proliferated rapidly in the Northeast after World War II as thousands of skilled welders from New England's wartime shipbuilding industry shifted to jobs in the civilian construction industry. (Courtesy MHD.)

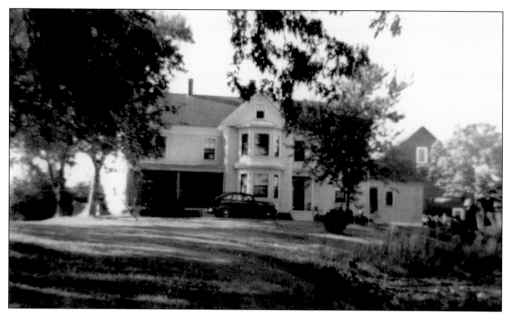

From Woburn, the new highway swung southwest through Burlington, where it narrowly missed the Crawford family farmhouse, not far from the intersection of Newbridge Avenue and Lowell Street in the Wynnmere section of the town. The highway cut between the Crawfords' farmhouse and the farm itself, requiring the family to take a circuitous mile-long route to access their fields directly across Route 128. (Courtesy Herb Crawford.)

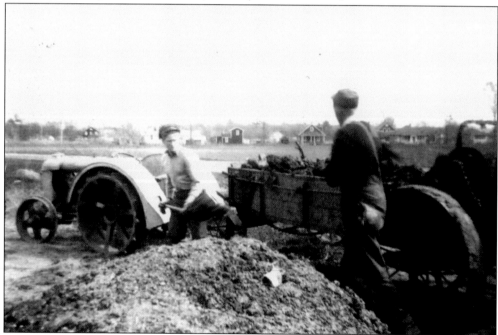

This Crawford family snapshot shows Andrew Crawford (right), his neighbor Charlie Gay, and a Fordson tractor spreading pig manure across the Crawford fields in the 1940s with Winn Street in the background. The view looks west from what is now the median strip of the new highway. (Courtesy Herb Crawford.)

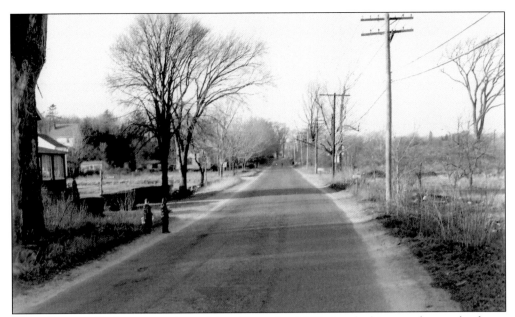

Winn Street in Burlington is pictured in a December 1949 view looking north past the future location of the Route 128 overpass. The Crawford farm would be to the right in this view. A 1937 Massachusetts guidebook described the town of Burlington (population 2,146) simply as "an agricultural community." The construction of the new Route 128 would transform the once bucolic town into a regional hub of commerce and industry. (Courtesy MSA.)

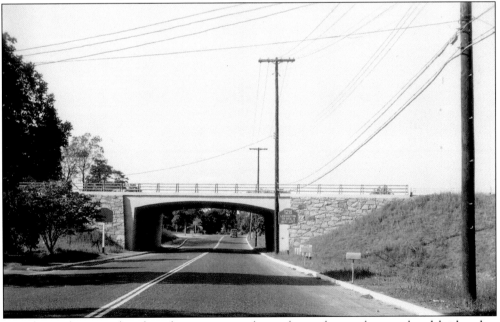

An identical view, taken less than two years later, shows the newly completed bridge that carries the new Route 128 over Winn Street. The handsome stonework that faced the rigid-frame concrete bridges all along the new stretch of Route 128 were among the last examples of monument-inspired public works projects in Massachusetts, whose designers prioritized aesthetic quality over the lowest cost. (Courtesy MSA.)

This December 1949 view looks north up Cambridge Street in Burlington at the location of the future Route 128 interchange. Cambridge Street in Burlington had been designated as U.S. Route 3 in 1926, when the first nationwide route numbering system (a product of the 1921 Federal-Aid Highway Act) was implemented. Note the Texaco filling station in the distance. (Courtesy MSA.)

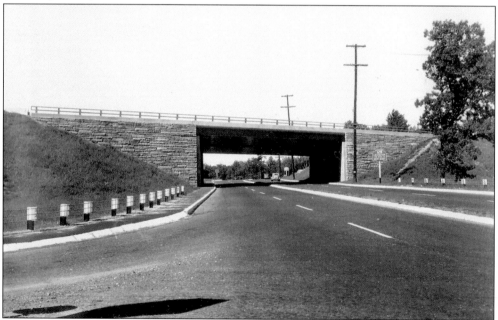

Here, in the fall of 1951, is a similar view of Cambridge Street, showing the recently completed interchange. Note that Cambridge Street (today Route 3A) has been widened and modernized to accommodate both through-traffic and vehicles using one of the new Route 128 interchange ramps. All along the new highway's alignment, the cost of modernizing local roads to accept interchange traffic constituted a major portion of the overall expense. (Courtesy MSA.)

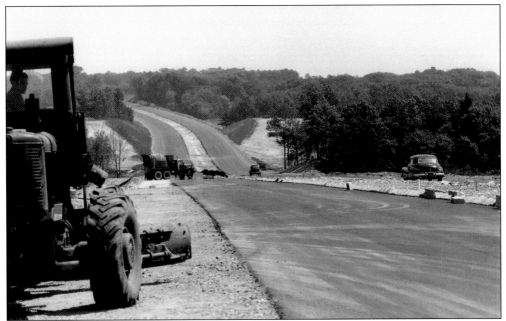

Dual ribbons of asphalt curve gracefully through the landscape in Burlington near the Cambridge Street interchange in June 1951. The Massachusetts Department of Public Works experienced major problems with drivers, bicyclists, and even mothers with their baby carriages taking the liberty of test-driving the nearly completed new highway in the weeks before it opened to traffic in August 1951. (Courtesy MHD.)

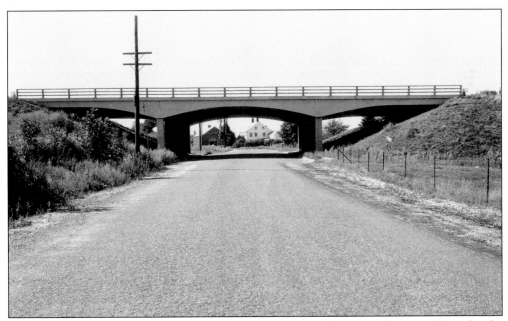

This view looks northwest along South Bedford Road in Burlington in August 1952 under the unusual combination concrete arch-and-beam bridge that carried the new Route 128 over the local street. The house and barn in the background would soon make way for the Burlington Woods Office Park. (Courtesy MSA.)

From Burlington, the new highway's path continued south through Lexington and spelled the end for these homes on the unpaved Valley Road. The rail bed of the Boston and Maine Railroad's Lexington and Arlington Branch is just visible to the far left. This 1949 view looks northwest from roughly the point where the new highway would pass under the Boston and Maine tracks (today the Minuteman Bikeway). (Courtesy MSA.)

This easterly view from January 1950 shows homes and a barn along Massachusetts Avenue in Lexington just prior to the start of construction of the new Route 128 in this area. This photograph was taken from roughly the edge of the highway's right-of-way, with Paul Revere Road (at the time called Old County Road) in the foreground. (Courtesy MSA.)

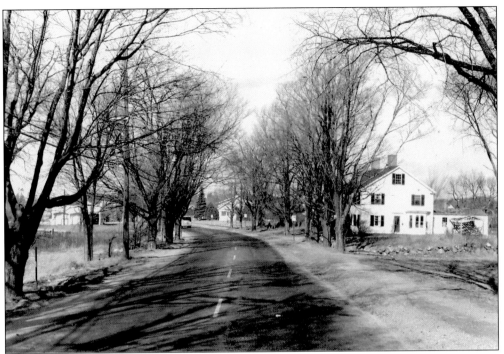

This view looks north in January 1950 from the location of the future interchange between the new Route 128 and Bedford Street (Routes 4 and 225) in Lexington. The handsome white house to the right has only months to live. (Courtesy MSA.)

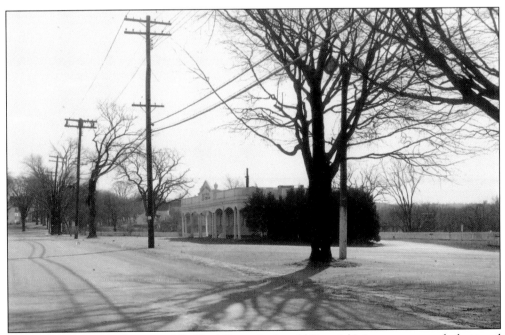

Shown in this southerly view of Bedford Street is the old Buttrick's ice-cream stand, shuttered for the season in the fall of 1949, never to reopen. The property was demolished in the early spring of 1950 to make way for the new highway's interchange ramps. (Courtesy MSA.)

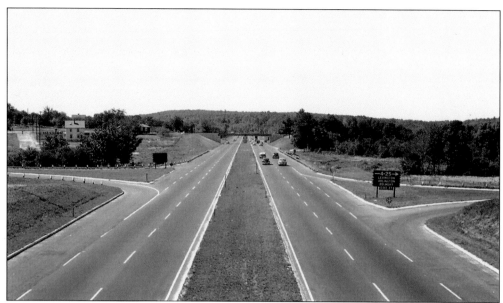

This photograph, taken on a Monday morning in the late summer of 1952, looks southwest from the overpass of what was then Route 25 (today Route 225) in Lexington over a lightly traveled Route 128. Note the sharp curves of the exit and entry ramps and the stub of Myrtle Street to the far left, cut off by the new highway's right-of-way. (Courtesy MSA.)

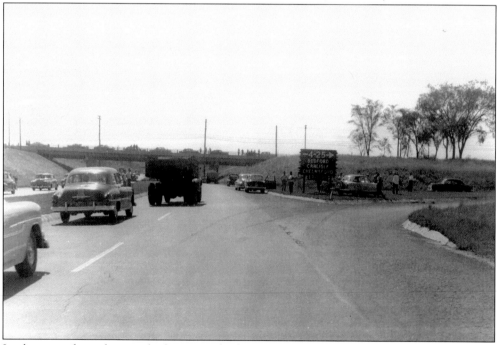

In this view from the new highway's early days, a motorist has tried to take the westbound Route 25 exit too abruptly and has run off the road into the exit sign. When the highway was widened in this area in the early 1960s, the addition of proper approach and merging lanes and the increased radius of reconstructed interchange ramps improved the highway's safety. (Courtesy the Lexington Historical Society.)

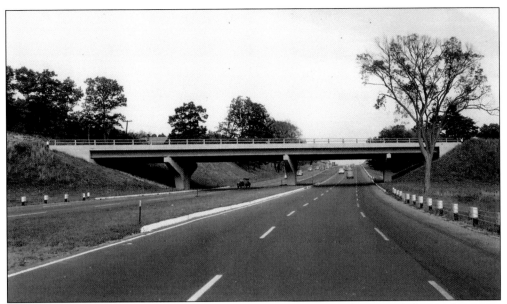

The Grove Street overpass in northern Lexington was built by the Peter Salvucci Company. The use of rolled steel beams and cantilevered concrete bridge piers made this structure one of the most modern bridges on the new highway. It was demolished in 1963, when the highway was widened to eight lanes in this area. (Courtesy MSA.)

This curious northeasterly view shows the remains of Weston Road in Lexington just north of the Route 2 interchange in the late fall of 1951. The locations of expensive interchanges and grade separations along the new Route 128 were determined by department of public works engineers based on studies of traffic volumes on the local roads. If the volumes proved below a certain threshold, roads were rerouted or simply dead-ended. (Courtesy MSA.)

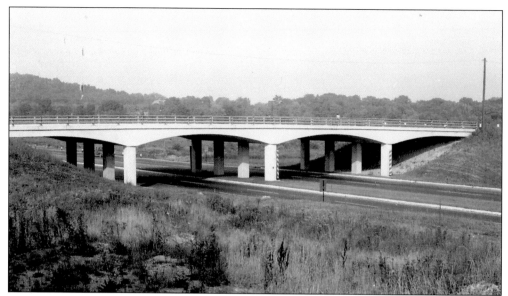

From Lexington, the highway continued south into Waltham, where it passed under the unusual concrete haunch-beam Trapelo Road bridge. Taking a cue from the designers of the Merritt Parkway, William Callahan deliberately (and at no small cost) varied the bridge designs on the 22-mile stretch of new highway. These bridges were replaced with a single utilitarian design (mandated by the Federal Highway Administration) when the highway was widened in the early 1960s. (Courtesy MSA.)

Main Street in Waltham (Route 117) is shown in March 1950, looking west from the point where the new Route 128 would pass beneath. Bear Hill is in the background to the left, and many of the homes in the foreground have only months before they are demolished. (Courtesy MSA.)

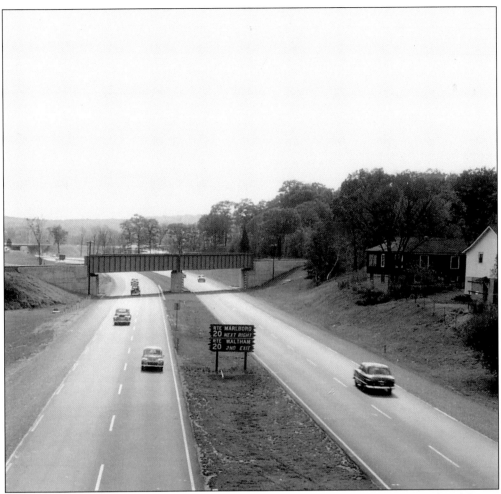

This view looks south from the Main Street bridge in Waltham over the completed Route 128 in October 1952. The structure carrying the Boston and Maine Railroad's central Massachusetts line (now abandoned) over the new highway is visible in the center. Within a decade, the homes to the right would fall victim to the highway's widening from four lanes to eight. Note the difference in the quality of paving between the travel lanes and the breakdown lanes. Safety devices like guardrails were not installed until the highway was widened in the early 1960s with fiscal assistance from the Federal Highway Administration, which mandated that federally funded highway projects conforming to interstate highway standards include guardrails. (Courtesy MHD.)

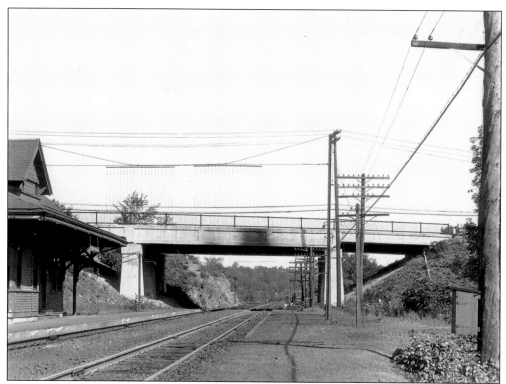

Here is Waltham's old Stony Brook station on the Boston and Maine Railroad's Fitchburg line in August 1936 shortly after the completion of the new Boston Post Road (Route 20) overpass. The Boston and Maine ceased passenger service on the line in 1953 and demolished this station that same year. The Massachusetts Bay Transportation Authority (MBTA) resumed passenger service in the late 1970s but skipped Stony Brook. Route 128 passed just to the right of this view. (Courtesy MHD.)

This view looks east along Route 20 toward Waltham at the point where Route 128 will pass underneath. Clearly visible to the left is a portion of the low-lying and swampy Bear Hill Valley through which the department of public works right-of-way engineers routed the new highway. (Courtesy MSA.)

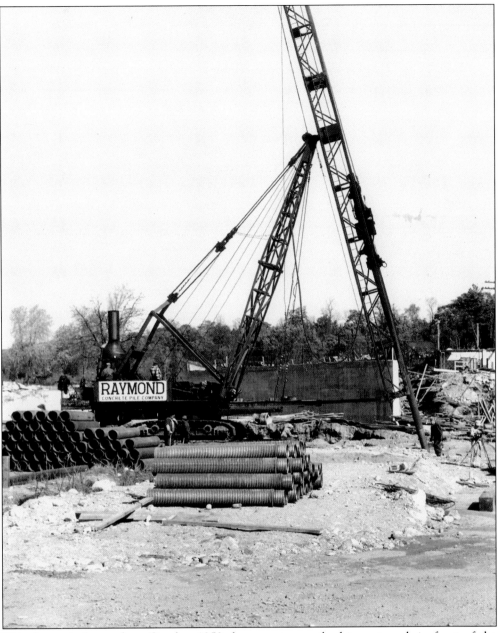

This dramatic image from October 1950 shows a steam pile driver at work in front of the eastern abutment of the Route 20 overpass in Waltham. In areas along the new highway's alignment where the soil was wet or of poor bearing capacity, clusters of deep piles had to be driven in order to support bridge abutments and piers. Note the puff of steam emitted from the driving hammer to the upper right. (Courtesy MHD.)

This house along Bear Hill Road in western Waltham has only months to live in this northeasterly view from January 1950. Modern-day drivers may be familiar with the large radio towers that were erected in this area in the wake of the highway's construction. (Courtesy MSA.)

Shown in January 1950 is the view from Bear Hill Road in Waltham over the low plain through which the new Route 128 would pass, roughly from the center right to the lower left. Bear Hill Road, which cuts across the new Route 128 alignment in this view, was rerouted to run parallel to the new highway. (Courtesy MSA.)

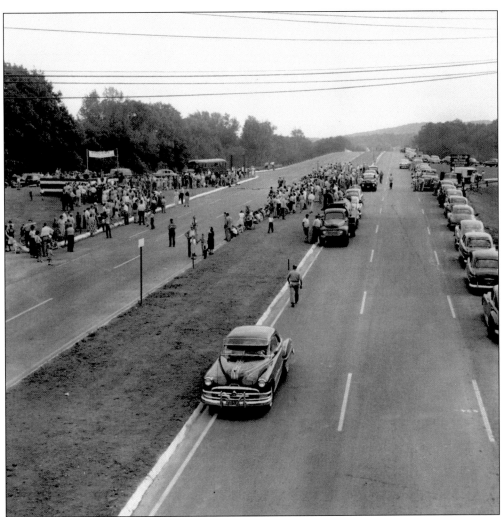

When the new highway was inaugurated on August 23, 1951, every town along the route wanted a piece of the action. The opening ceremony began at the Route 9 interchange in Wellesley and continued north in an official motorcade. Seen here is the scene at the Route 20 interchange in Waltham, where Gov. Paul Dever stopped to make a brief speech before continuing on to further stops (and ceremonies) in Lexington, Burlington, Woburn, and Wakefield. (Courtesy the Waltham Museum.)

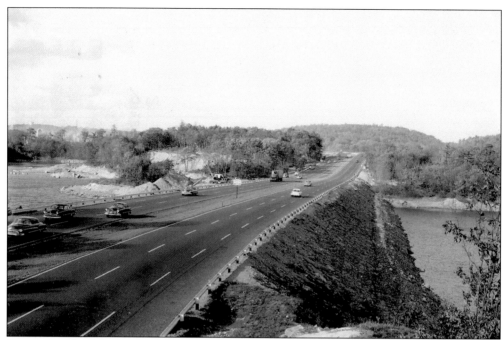

Pictured in the fall of 1952 is the earthen embankment that carries the new highway through the Stony Brook Reservoir between Weston and Waltham. At the time, the Stony Brook was part of the watershed serving the water supply for the city of Cambridge. In the era before the passage of the National Environmental Policy Act in 1969, construction of an express highway through a public water supply was an acceptable practice. (Courtesy MSA.)

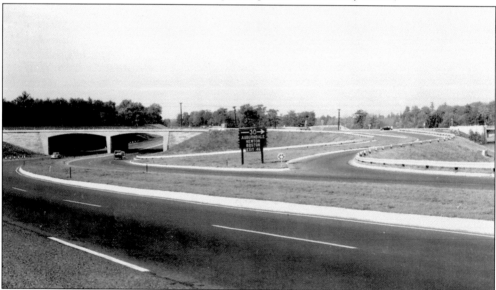

The interchange with Route 30 (Commonwealth Avenue) on the Newton-Weston border is pictured in October 1952. The handsome stone-faced concrete-arch bridge saw less than 10 years of service before being demolished and reconstructed to accommodate the widening of the highway to eight lanes in this area. At the time of the new highway's construction, Route 30 was one of the major routes into downtown Boston from the west. (Courtesy MSA.)

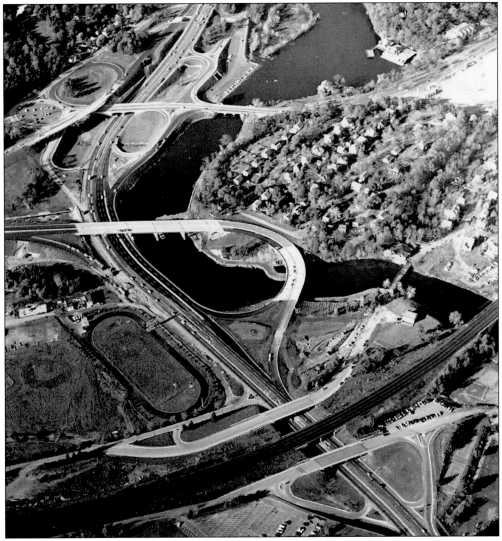

This aerial view, dating from 1957, gives a good overview of the complex series of interchanges and overpasses that served the new highway as it skirted the Charles River between Weston and Newton. From top to bottom are the Route 30 interchange, the old Massachusetts Turnpike interchange (completed in 1957), the small exit and entry ramps specially constructed to serve Boston University's Nickerson Field, the Boston and Albany Railroad's main-line overpass, and the Recreation Road interchange that served the Riverside Recreation Grounds. (Courtesy the Perini Corporation.)

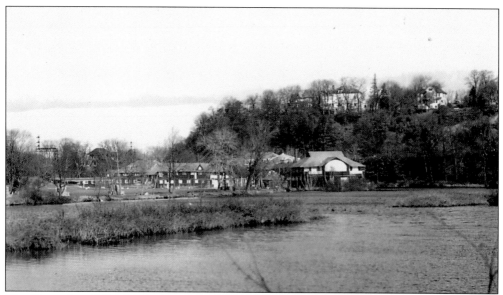

This December 1949 view looks north along the alignment of the new Route 128 at the point where it will cross the Charles River. At the center is the old Riverside Recreation Grounds, which offered canoe rentals, bowling, and a swimming pool that connected directly to the Charles River. In the background is Pigeon Hill in Newton, a neighborhood that would be devastated by the construction of the Massachusetts Turnpike Extension beginning in 1962. (Courtesy MSA.)

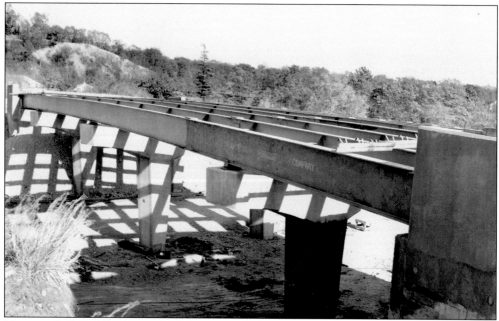

Here, in the late fall of 1950, is the Recreation Road overpass under construction in Weston. Ultimately, this small interchange would be bypassed by the reconstruction of the new highway in this area in the early 1960s, when the alignment of the highway was moved west to accommodate a large interchange with the Massachusetts Turnpike. Note the significant camber of the steel beams in this view. (Courtesy MHD.)

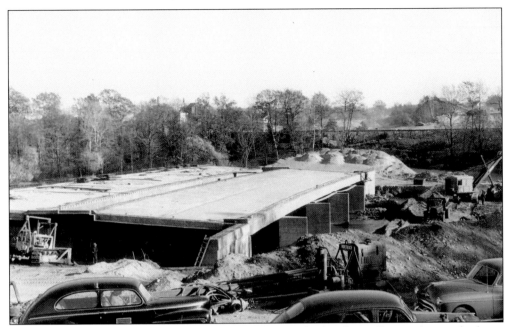

Pictured on a late afternoon in October 1950 is the new bridge that will carry the new highway over the Charles River Bridge between Weston and Newton. This view looks southeast from the Weston side of the river and shows the bridge's cast-concrete piers and deck. The embankment of the Boston and Albany Railroad's Riverside loop is visible in the distance, seen here before being reconstructed to carry the tracks over the new highway. (Courtesy MHD.)

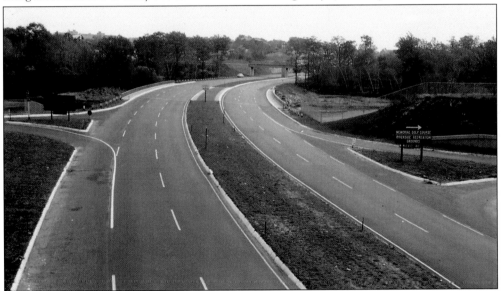

This similarly situated view, taken two years later, gives an interesting study in the new highway's early evolution. The new Route 128 was initially touted as a convenient means of access to many recreational and tourist destinations in eastern Massachusetts. This tight interchange provided access to the Riverside Recreation Grounds and golf course in Weston but was bypassed by the widening in 1962 as Route 128 shifted from a weekend pleasure route to a major regional transportation corridor. (Courtesy MSA.)

This view looks southeast under the overpass of the Boston and Albany Railroad's Riverside loop toward the new Grove Street Bridge in Newton. This stretch of roadway was reconfigured into a northbound multiple-exit access route when Route 128 was widened in this area starting in 1962. Note the construction shack perched atop the ledge to the far left. (Courtesy MHD.)

The Quinobequin Road underpass in Newton is under construction in October 1950. In this view, the midday sun shines through the bridge's steel stringers, which are awaiting the installation of the concrete deck that will ultimately form the base for the new highway's surface. (Courtesy MHD.)

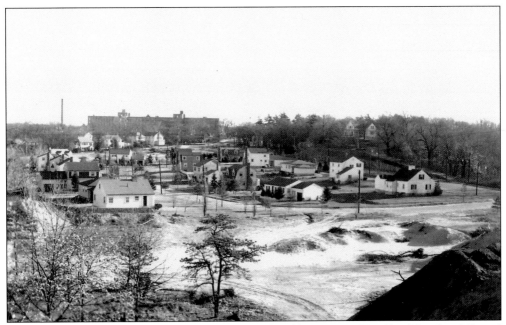

This January 1950 view, taken from atop a hill in the old nine-acre Woodland Sand and Gravel Company property just north of Washington Street (Route 16) in Newton Lower Falls, shows a crop of recently constructed homes that lie directly in the path of the new highway. The large Newton Hospital main building is visible in the background. (Courtesy MSA.)

Doomed homes along Washington Street are shown in January 1950. Rather than demolish these homes at public expense, the Massachusetts Department of Public Works recouped some of the taking costs by inviting sealed bids to remove the homes intact. At the center of this image is the former Bryant family home at 2159 Washington Street, for which two identical bids ($3,150) were received in March 1950. The winner was decided by a coin toss. (Courtesy MSA.)

This view looks south from Washington Street in Newton Lower Falls just after Christmas of 1949. In the background is the white home built in 1845 by Allan C. Curtis. In 1950, it became the Pillar House restaurant when George Larsen, a former Howard Johnson's manager, bought and expanded the house. The Pillar House closed in the summer of 2001 and was subsequently taken by eminent domain by the Massachusetts Highway Department. (Courtesy MSA.)

Here is an identical view in the fall of 1952. The old highway ramps that skirt the Pillar House lot in this view were reconfigured to loop around the other side of the building beginning in 1958, taking the brown house just visible to the far right and leaving the Pillar House with a large parking area facing the highway. (Courtesy MSA.)

94

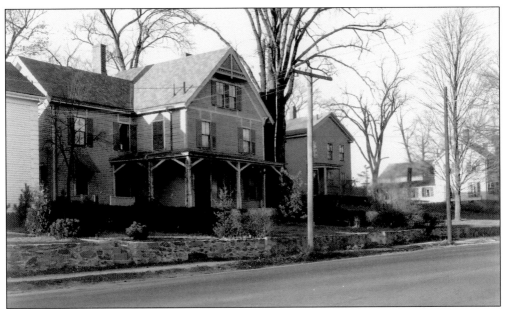

Directly across from the Pillar House was this home at 2197 Washington Street, owned by the Hegarty family since the 1920s. The homes in this December 1949 image have only a few months before they are torn down. Although the road stretched 22 miles through Boston's suburbs, only 94 homes were taken for the construction of the section of new highway from Wellesley to Lynnfield. (Courtesy MSA.)

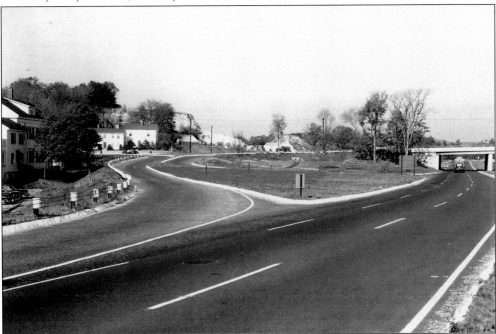

This view looks north across the Route 16 interchange in October 1952. The Hegarty home was just to the right of the two white homes on the far side of Washington Street, which were demolished when this interchange was reconfigured in 1958 and the Route 16 exit ramp was rerouted around the Pillar House. (Courtesy MSA.)

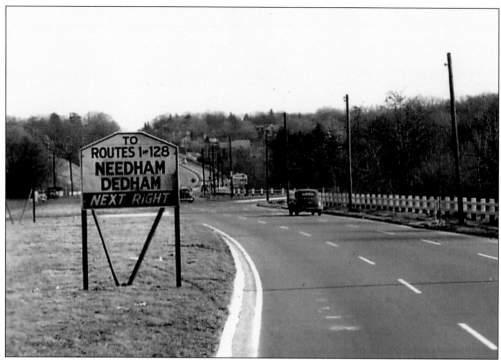

This 1949 view looks east along Route 9 toward the future location of the Route 128 interchange. The Reservoir Street exit led motorists to Greendale Avenue (the old Route 128) in Needham. At the time, Route 9 (also called the Worcester Turnpike) was the major east-west route across the Commonwealth. Like the old Route 128, it would soon be supplanted by one of William Callahan's highway creations—the Massachusetts Turnpike. (Courtesy MSA.)

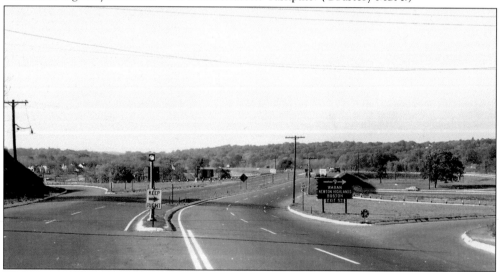

Old meets new on the Wellesley-Needham border in the fall of 1952. The old two-lane Route 128 expanded into the modern four-lane highway at this interchange with Route 9. Construction stopped at this point until the state floated additional highway bond issues in late 1952 that allowed construction on a section of the new Route 128 from this point south through Needham to begin in the fall of 1953. (Courtesy MSA.)

Four

BUILDING THE SOUTHERN ARC
1953–1958

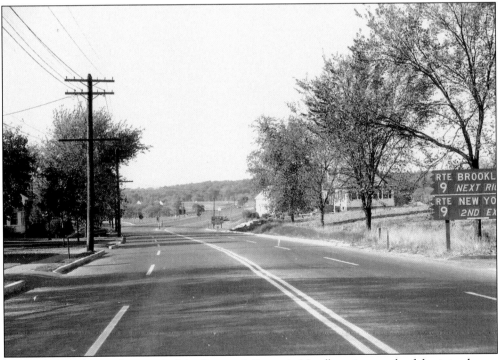

Shown here is the northern end of the Reservoir Street in Needham just south of the interchange with Route 9 in Wellesley. This section of Reservoir Street was designated Route 128 for less than three years, connecting the old Route 128 (Greendale Avenue) in Needham with the new highway, until the construction of the new Route 128 south of Route 9 cut the connection between Greendale Avenue and Reservoir Street in the summer of 1954. (Courtesy MSA.)

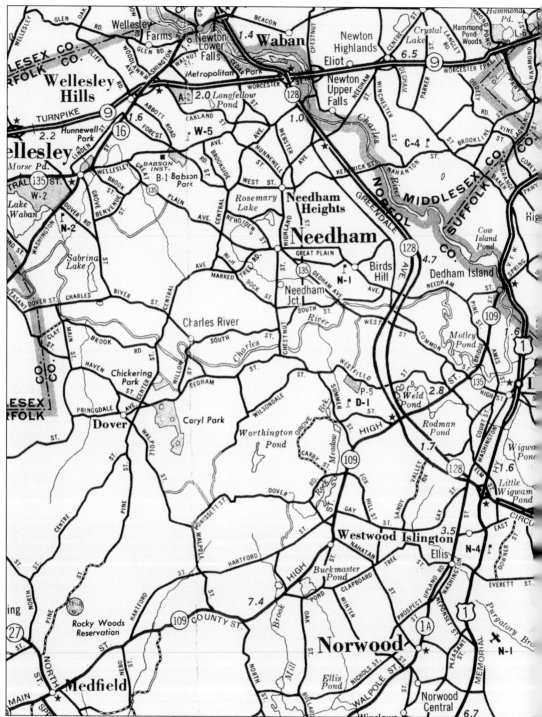

This *c.* 1957 map shows the southern portion of the new Route 128 between the Needham-Wellesley border and the eastern terminus in Braintree, where the new highway would join with the new Southeast Expressway. At the time this map was made, the new highway had been completed only as far south as the interchange with Route 138 in Canton, with a dotted line

showing the proposed alignment through the Blue Hills Reservation and to the Braintree Split. The immediate and unexpected popularity of Route 128 north of Route 9 led the department of public works to plan the southern half of the new Route 128 as a six-lane expressway as soon as design work began in 1952, less than a year after the northern section opened to traffic.

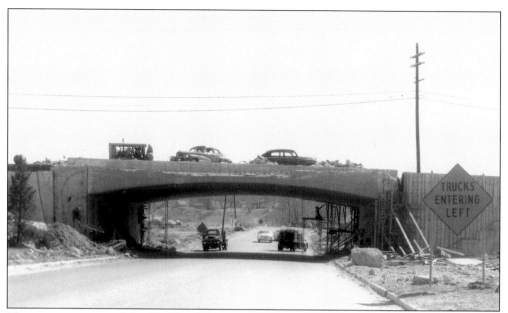

The reconstruction of the Highland Avenue bridge over Greendale Avenue in Needham is shown in 1954. One of the first bridges to be constructed over the old Route 128, the Highland Avenue bridge was built in 1931 just a few years after the Route 128 designation was applied. A portion of the old two-way Greendale Avenue would become the southbound barrel of the new divided highway in this area. (Courtesy MSA.)

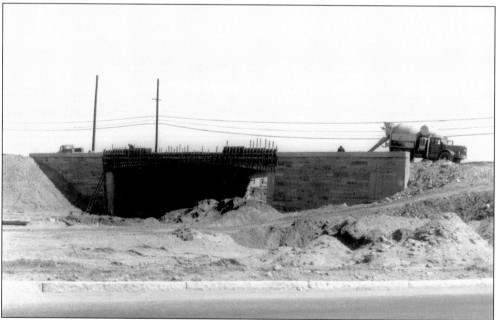

This view shows the newly constructed Highland Avenue overpass spanning the future northbound barrel of the new Route 128. This bridge survives today, but current plans to widen the highway to eight lanes from Route 9 in Wellesley to Route 24 in Randolph will require the demolition and reconstruction of many of these handsome stone-faced overpasses along the southern arc of the highway. (Courtesy MSA.)

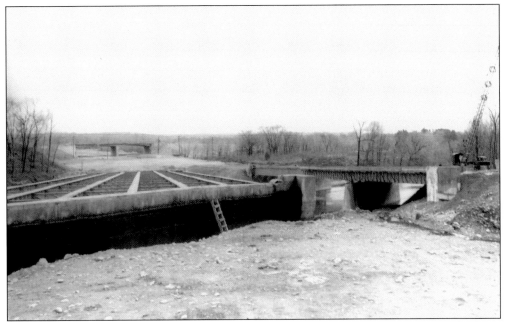

Taken in April 1955, this photograph shows the structures that will carry the new highway over the Charles River at the Dedham-Needham border. In the background is the Great Plain Avenue overpass in Needham. The new highway crossed the Charles River in three locations—here and twice in the Newton Lower Falls area. (Courtesy MSA.)

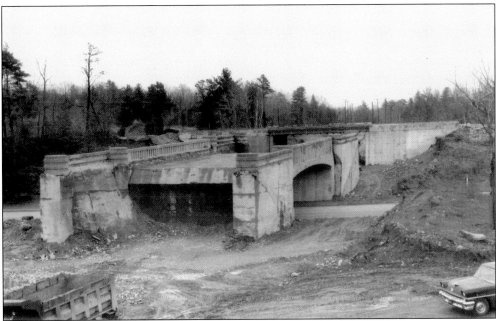

This April 1955 view shows a peculiar arrangement in Dedham, where the old concrete West Street (Route 135) bridge over the old Route 128 is being dismantled as a new structure that will carry the northbound barrel of the new Route 128 over Route 135 is nearly complete in the background. This east-facing photograph was taken from the newly constructed overpass that would carry the southbound barrel of the new Route 128. (Courtesy MSA.)

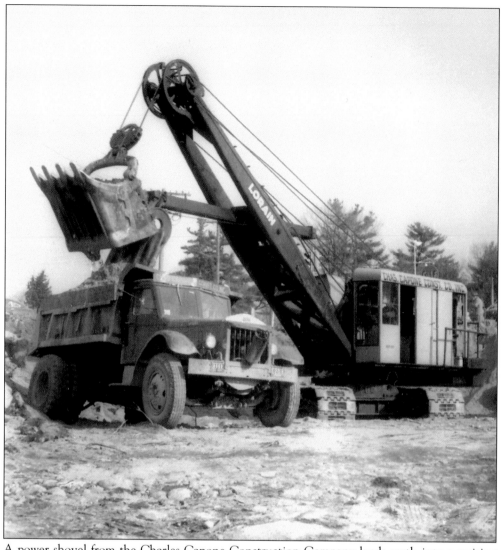

A power shovel from the Charles Capone Construction Company loads earth into a waiting dump truck along the old Route 128 in Dedham. The 1950s were a good time to be in the road-building business in Massachusetts, as nearly half a billion state dollars were spent on highway construction in the first half of the decade alone. (Courtesy MSA.)

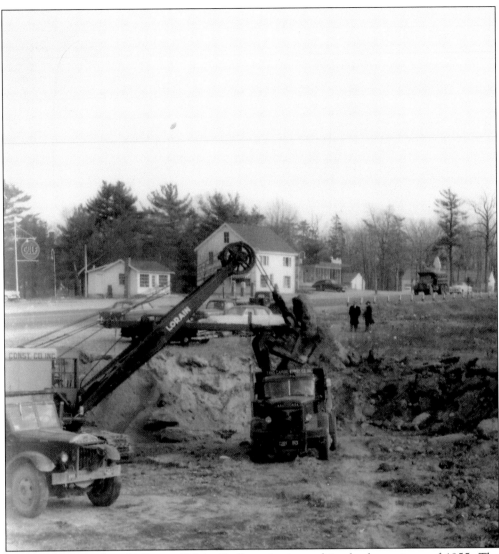

Earthwork along the old Route 128 in Dedham is pictured in the late winter of 1955. The presence of a Gulf filling station and a number of roadside stands is testimony to the importance of Route 128 as a major thoroughfare even before its expansion into a regional expressway. William Callahan was famous for deriding roadside facilities like these as dangerous, inefficient, and unsightly. In 1937, for example, he charged that "these stands have been springing up like weeds . . . and ruin the new road," after town officials in Saugus granted permits to roadside stands along the newly reconstructed Newburyport Turnpike (Route 1). (Courtesy MSA.)

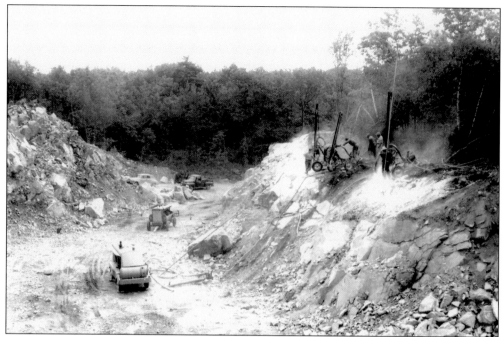

In this view dating from July 1955, drilling crews bore holes in a granite ledge in Dedham prior to blasting to make way for cloverleaf ramps serving Route 109. The drill rigs are powered by the gasoline-powered air compressors, visible to the left. (Courtesy MSA.)

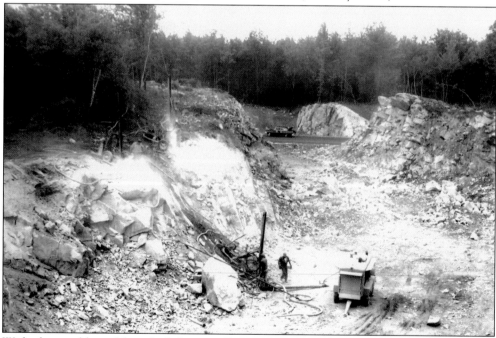

With the northbound barrel of the new Route 128 just visible between the granite ledges in the center, rock drills prepare the ledges for blasting. In this area, the rocky ledges were uncommonly fragmented and unstable once exposed, and the cuts had to be blasted back far beyond the edge of the actual roadway to avoid rockfalls into traffic. (Courtesy MSA.)

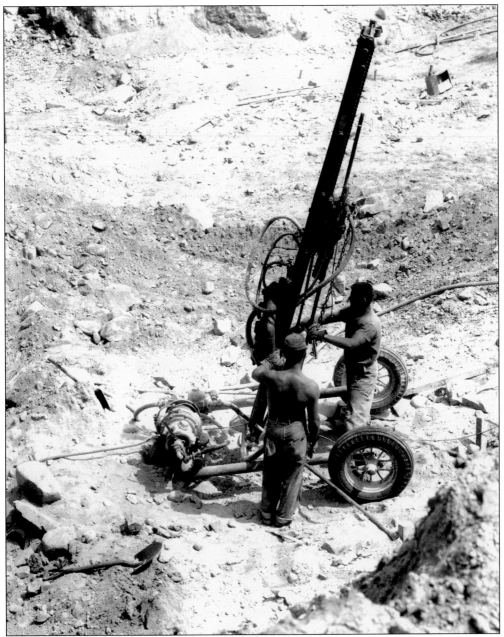

Here, in the summer of 1955, a drilling crew tends to a mobile drill rig at the future interchange with Route 109 in Dedham. This was a busy year for the Commonwealth's blasting contractors: in addition to the Route 128 work that summer, in the fall of 1955, former Massachusetts Department of Public Works chairman William Callahan began blasting his way through the Berkshires in western Massachusetts to make way for the Massachusetts Turnpike. (Courtesy William Litant.)

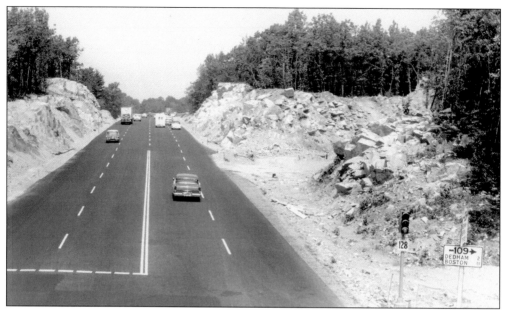

This peculiar arrangement appeared temporarily near the future interchange with Route 109 in Dedham in July 1955. With the interchange ramps still being blasted out of the ledge alongside the roadway, a short stretch of the future northbound barrel of the new highway served two-way traffic and retained a signalized at-grade intersection with Route 109, visible in the foreground. (Courtesy William Litant.)

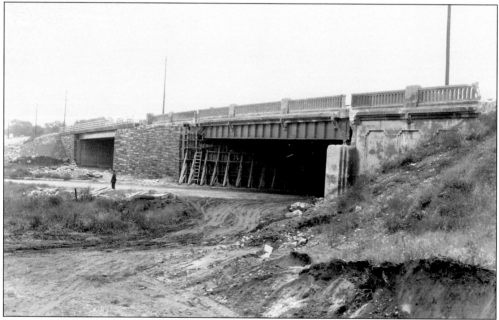

This view from the fall of 1955 shows the reconstruction and expansion of the old interchange between the old Route 128 and the Providence Turnpike (Route 1). The old Route 1 overpass spanned the old two-way, single-barrel Route 128. Beginning in 1954, a second span was added to accommodate a second parallel three-lane roadway (the new highway's southbound lanes), and the old span was widened to accommodate an additional lane. (Courtesy MSA.)

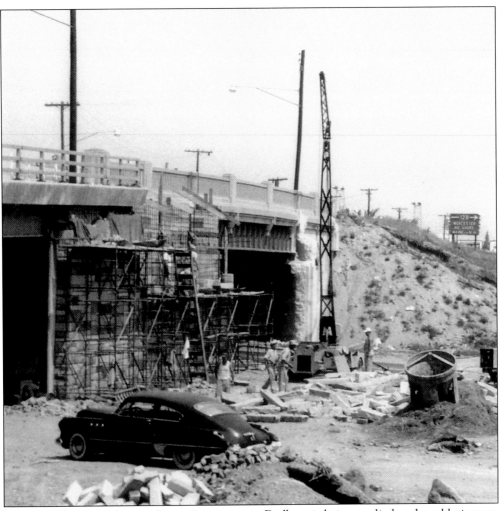

The stone facade of the new Route 1 overpass in Dedham is being applied under a blazing sun in the summer of 1955. Stone blocks are strewn around the masons' scaffolding, waiting to be lifted into place by the small crane at the center. (Courtesy William Litant.)

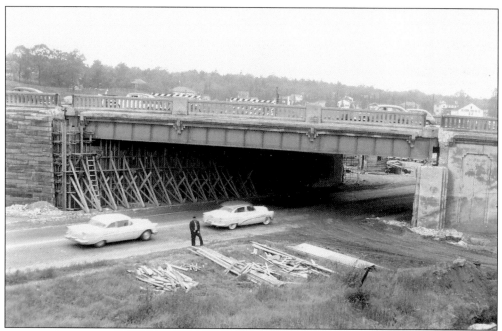

The old Route 1 overpass was constructed in the mid-1930s and spanned the two-lane roadway with the massive riveted girders shown here. Of particular curiosity in this view is the contrast between the simple concrete facing on the old (right) bridge abutment, built in the cash-strapped depression years, and the handsome stone facing (left) applied to the new bridge during the 1950s, when highway construction money was relatively plentiful. (Courtesy MSA.)

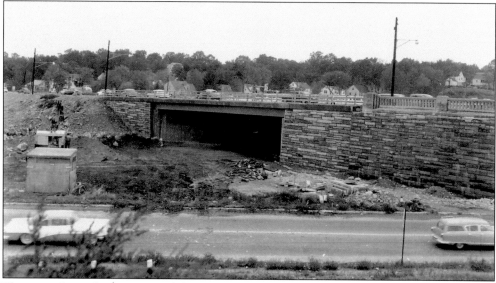

This view shows the new span of the Route 1 overpass nearing completion in the fall of 1955. Unlike the stone-faced bridges on the section of the new Route 128 from Wellesley to Peabody, this bridge survives today. By the time construction on the southern portions of the new highway started, traffic had so exceeded projections on the four-lane northern portion that the Massachusetts Department of Public Works planned the southern section as a six-lane roadway from the start. (Courtesy MSA.)

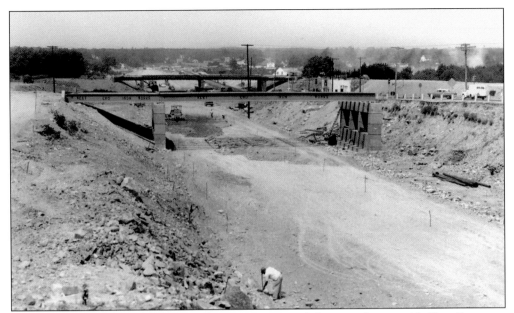

Pictured in the summer of 1955 is the construction of the interchange with East Street on the Dedham-Westwood line. To the right, the old Route 128 remains in operation in both directions while work proceeds on the future southbound barrel of the new highway. Once it is completed, the old Route 128 will be closed and reconfigured into the northbound barrel. (Courtesy William Litant.)

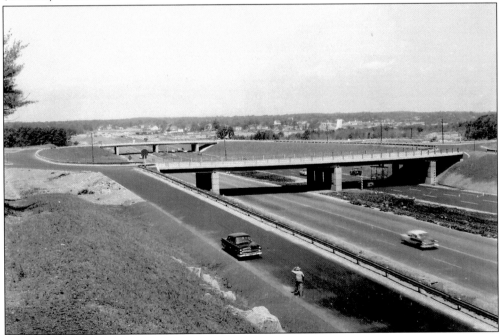

A similar view, taken about a year later, shows the completed East Street interchange. This northwesterly view clearly shows the odd rotary-like interchange design necessitated by the intersection of several local streets at this point. Just beyond the interchange is the current site of the Dedham Corporate Center. (Courtesy William Litant.)

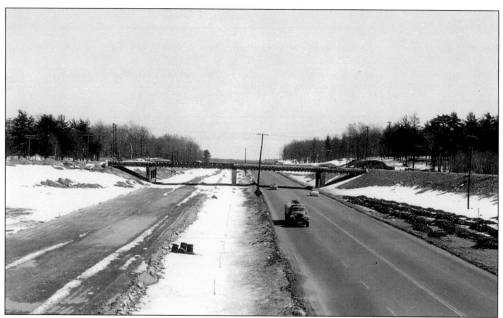

This view from the spring of 1956 looks southeast from the northern East Street rotary overpass and shows the future southbound barrel of the new Route 128 open to two-way traffic to the right, with the northbound barrel of the new highway under construction to the left. (Courtesy MSA.)

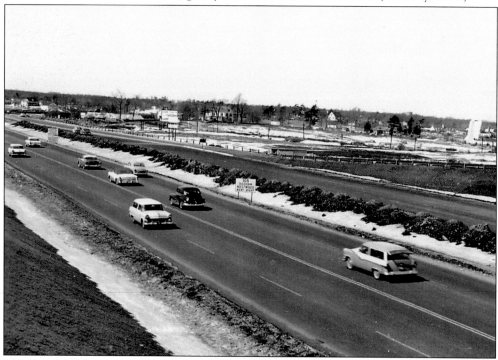

This April 1956 view in Dedham demonstrates the construction phasing on much of the work in this area. In order to avoid disrupting traffic on the existing Route 128, contractors completed the new southbound lanes of the new highway and opened them to two-way traffic while the old two-way highway was reconstructed into the new northbound lanes. (Courtesy MSA.)

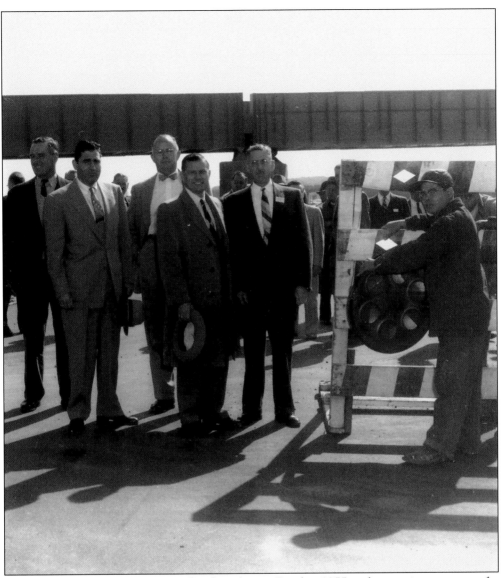

Public works engineers and state officials gather in October 1955 at the opening ceremony for the section of new Route 128 between Route 9 in Wellesley and Great Plain Avenue on the Needham-Dedham border. At the center, wearing an overcoat and with his hat in his right hand is Massachusetts Department of Public Works commissioner (and future governor) John A. Volpe, who took over the construction effort from William Callahan in the spring of 1953. (Courtesy MSA.)

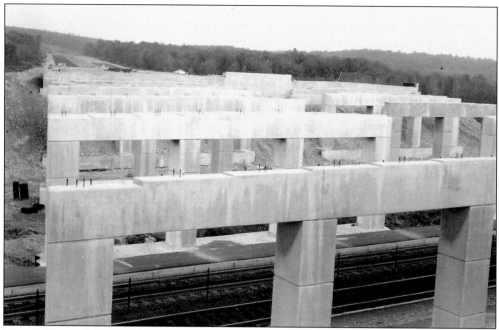

This 1955 view looks north from the location of the current Route 128 MBTA station. At the time, the Boston and Providence line of the New York, New Haven, and Hartford Railroad stopped only at Green Lodge in Dedham and at Canton Center. The line was constructed by the Boston and Providence Railroad Company and was one of the first passenger railroads in the United States at the time of its construction between 1832 and 1835. (Courtesy MSA.)

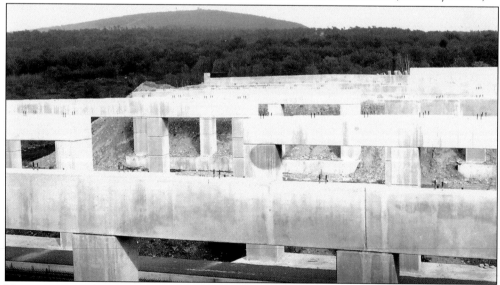

Here is an easterly view over the New Haven tracks with Blue Hill in the distance. A fierce public debate began in March 1955 over the plans of the Massachusetts Department of Public Works to run the new highway through the center of the Blue Hills Reservation. Local representative Harold Putnam charged that the department had deliberately hidden a study detailing an alignment that would have routed the highway south of much of the reservation. Putnam and the alternate alignment were ignored. (Courtesy MSA.)

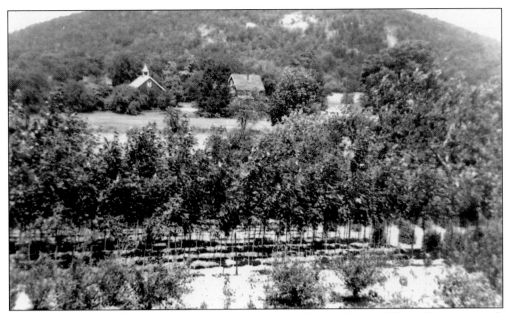

Pictured is the old Blue View Nursery on Washington Street (Route 138) in Canton. Joseph Cogliano started working at the nursery as a boy in the 1930s before purchasing it from its owner James Taylor in 1950. The Massachusetts Department of Public Works took the property in April 1955 to make way for the Route 138 interchange but refused to compensate the Coglianos for the value of the nursery stock growing on the property. (Courtesy John Cogliano.)

The view from the Cogliano home is shown in a 1954 view looking toward Washington Street. Joseph Cogliano took the Massachusetts Department of Public Works to court and won a landmark ruling that forced the department to compensate him for the value of the lost nursery stock in addition to the land. In a curious twist of history, Joseph Cogliano's son John was appointed commissioner of MassHighway (the successor to the department that the family sued in 1955) in February 2002. (Courtesy John Cogliano.)

This remarkable annotated aerial view produced by the Massachusetts Department of Public Works in 1958 clearly shows the narrow, winding old Route 128 (Blue Hill River Road) in Canton, in stark contrast to the broad arcs of the new highway and the high-speed interchange with the future Route 24. Despite the public outcry about the proposed Route 128 alignment through the Blue Hills Reservation, the view championed by Quincy official Cranston Smith that the new highway's "importance to traffic relief far outweighs the loss of a few acres of the reservation" won the day. (Courtesy MHD.)

Five

DEVELOPING AND REBUILDING ROUTE 128

When ground was broken for the new highway in the spring of 1950, only the most farsighted of planners, developers, and public officials foresaw the incredible growth that was to occur around Route 128, and none yet perceived the degree to which the new highway would realign and redefine the region's economy. The unprecedented scale of development that almost immediately followed the construction of Route 128 was the product of a unique confluence of factors that only a very few fully understood. The full impact of this subtle union of economic, political, and popular forces did not become clear to even the most casual observer until the economic boom was well under way and manifested itself in the form of daily traffic jams, soaring real estate values, and the transformation of once bucolic suburban towns into regional centers of employment and retail destinations.

By 1950, the once undisputed hub of New England's economy had fallen on hard times. Hobbled by a combination of high property taxes, congested streets, poor regional transportation access, and a precipitous decline in maritime activity in the early postwar years, Boston's appeal as a viable market for major commercial development had been waning since the onset of the Great Depression. A period *U.S. News and World Report* article noted that Boston appeared to be "dying on the vine." Meanwhile, across the Charles River in Cambridge, the Massachusetts Institute of Technology (MIT) was enjoying the start of what would become a decades-long stream of billions of dollars in federal research money. While the private sector capital markets soundly rejected the city of Boston as the site of any new development, public money flowed into MIT just across the Charles and helped spawn one of the most remarkable waves of entrepreneurial activity of the 20th century. The list of companies founded by MIT graduates and affiliates during those early years of copious research dollars and rapidly advancing technology included what would become some of the nation's most prominent electronics corporations. However, these companies needed more than just dollars and bright minds—they needed research, manufacturing, and distribution facilities, and homes where their employees would want to live and from which they could easily drive to work.

Commercial and industrial architecture had undergone a rapid evolution in the immediate postwar years, shifting away from the multistory concrete-frame warehouse and manufacturing prototypes that replaced brick and beam structures in the early decades of the 20th century. By the early postwar years, both industrial and office concerns (other than those deliberately locating in the downtown core for business purposes) found that sprawling, one- or two-story steel-frame structures—based on the assembly-line prototype that had been perfected during the war—made for less expensive construction and more efficient operations. Save for a few pockets of vacant land near Kendall Square located close to the MIT campus, however, land values and property taxes in most of the dense urban cores of Boston and Cambridge were too high—and transportation access too poor—for these emerging industries to locate new research and manufacturing facilities in close proximity to the institution that formed the core of the region's high-tech economy.

In stark contrast to the impediments to development that plagued the region's urbanized core, acreage along the planned alignment of the new Route 128 had little value prior to the highway's construction—the highway had in fact been deliberately routed through low-value areas in order to minimize costs, and it was not burdened by high municipal taxes. The plans

of the Massachusetts Department of Public Works to align the new Route 128 outside of the dense town centers through which the old route passed placed the new divided highway in previously remote locations where land values were orders of magnitude lower—and regional transportation access far better—than most sites in Boston or Cambridge.

In addition to the cheap and plentiful land that was necessary for the large-scale development of modern research, manufacturing, and distribution facilities, the suburban region through which the new highway passed also boasted another key ingredient that would ultimately fuel the rapid growth along the new highway. The postwar shuttering of the region's defense plants, the rapid decline in many of New England's traditional industrial sectors, and the long downfall of Waltham's venerable watch industry had left a large pool of unemployed but skilled suburban workers. Most of these workers possessed a technical proficiency that was easily adapted to suit the labor needs of the emerging electronics industry and other manufacturing concerns that would ultimately opt to locate along the new urban periphery.

Even as construction of the new highway began in 1950, however, there was no immediate rush to locate near William Callahan's "road to nowhere." As early as 1947, the David Nassif Company built a $4 million modern industrial park on Needham Street in Newton (the old Route 128) that came to be known as "the Miracle Mile," but it would take the farsighted vision of one man—and the free-flowing capital of one company—to bring the true economic potential of the new highway to full fruition.

In late 1948, Gerald Blakeley was several months into a new job with Cabot, Cabot and Forbes, a Boston-based development firm, when he began studying the state public works department's 1948 *Master Highway Plan for the Boston Metropolitan Area*. The plan proposed the construction of six major expressways radiating out into the city's suburbs from an eight-lane loop highway closely encircling Boston called the Inner Belt. The proposed Inner Belt alignment cut through Cambridge just behind MIT, and the radial highways would, Blakeley noted, provide easy access from areas along Route 128 (the planning for which was independent of the master plan) directly to MIT. "Everyone wanted to be near MIT," Blakeley recalled. "The first question industry executives asked was 'what's the driving time to MIT?'" Blakeley was among the first to fully recognize the economic potency of this combination of cheap land along Route 128, easy automobile access to MIT and downtown Boston, a ready labor pool, and the burgeoning demand for modern, low-rise research, manufacturing, and distribution space in the Boston metropolitan area. This recognition came to him, he recounts, late one night during his early days at Cabot, Cabot and Forbes, when, after slipping into the bathroom to avoid waking his wife, he scribbled a broad and far-sighted outline for the future of commercial development along Route 128. Blakeley's vision included well-planned and handsomely appointed campuslike settings for new industrial and research facilities located near local interchanges all along the new highway's alignment. It also included a revolutionary model for the delivery of such projects—the single source or "package" procurement, whereby a client corporation could retain Cabot, Cabot and Forbes to provide a fully permitted site, design a new facility using an in-house architect, provide short-term debt financing for its construction, and construct the new building with an in-house contractor. Blakeley's recipe for development was quickly adopted by Cabot, Cabot and Forbes, which made major investments acquiring large tracts of land near planned or recently completed interchanges, lobbying municipal governments to amend local zoning to allow the new commercial uses, and marketing their new "package" development model to established national corporations and emergent local industries alike.

The Cabot, Cabot and Forbes plan worked. Its project managers found ready support for the proposed zoning changes in most cities and towns along the new highway, because the proposed high-value commercial uses added to the local tax base without demanding significant incremental municipal expenditures on education or human services. Development-friendly zoning initiatives in Waltham led companies such as Sylvania, Canada Dry, transistor giant Clevite, Polaroid, and Fruehauf to site their offices and plants there, while Wilmington welcomed defense contractor AVCO, which built an $18 million plant that employed 3,500

workers. In some cases, the public sector provided more than regulatory incentives to lure industries to specific locations. In Danvers, for example, the Massachusetts Department of Public Works built a new interchange and overpass at Endicott Road to provide access to new developments. Farther west, the city of Woburn teamed up with Middlesex County to provide an access road for a new Sylvania manufacturing plant. In all, between 1950 and 1957, capital investment in new commercial facilities along Route 128 approached $100 million, and the value of newly constructed residential developments in the suburbs along the Route 128 corridor during the same period topped $400 million. The highway once lambasted as "Callahan's folly" had resulted in $500 million in new development in less than a decade. By contrast, not a single major commercial building was constructed in downtown Boston during that same period.

During the 1950s, Route 128 grew rapidly into a mecca for the region's electronics industries and many national corporations. In his study of the development of Route 128, Donald Levitan noted that in 1955, there were 53 commercial enterprises located along Route 128. Just four years later, there were 223. By 1967, there were 729, employing some 66,000 workers. Land values along the highway had risen from a preconstruction average of $450 per acre to over $5,000 in 1957, with some prime locations fetching close to $20,000. Industrial and office developments were complemented by major retail destinations like the Liberty Tree and North Shore Malls, Burlington Mall, and South Shore Plaza, and many once bucolic suburban towns along the new highway strained to keep pace with an unprecedented wave of residential development. In Wakefield, one visionary even attempted to create New England's own version of Disneyland, called Pleasure Island Amusement Park, which he located next to Route 128. By 1959, the *Boston Globe* beamed that "the Road to Nowhere is now the Hub of Everything."

Accompanying the developments that gave the region a new economic axis were the motorists who could now live, work, and shop without ever leaving the Route 128 corridor. From a daily average of 22,000 cars the first month following its opening in the summer of 1951, by the late 1950s, daily volumes approached 40,000, and traffic conditions on the four-lane section of the highway had severely deteriorated. In January 1959, department of public works commissioner Anthony DiNatale announced that the road would be widened to six and eight lanes between Wellesley and Lynnfield but curiously explained that the need for the expansion was "due to the unforeseeable industrial expansion along the highway." To William Callahan, Gerald Blakeley, and a handful of others, the growth along Route 128 was not so much unforeseeable as it was inevitable. DiNatale's announcement delighted Callahan, who often enjoyed reminding his audiences that his original 1949 plan, which the federal Bureau of Public Roads rejected as unreasonably optimistic, had called for the construction of Route 128 as a six-lane road from the start. By 1964, the Massachusetts Department of Public Works had spent over twice as much widening the northern section of Route 128 as Callahan had spent building it just a decade earlier.

The development boom along Route 128 continued into the 1960s and rose and fell with the region's economy through the 1970s and 1980s. The "Golden Arc" attracted many of the nation's largest high-tech firms like Wang and Digital during the "Massachusetts Miracle" years of the second and third Dukakis administrations. Even in the depths of the recession that followed, however, the volume of vehicular traffic on the aging highway continued to increase. By the late 1990s, at some locations, nearly 200,000 vehicles traversed the highway whose onetime critics believed would fail to attract even a tenth of that number.

The following chapter examines the early years of growth along the new highway and documents the emergence of Route 128 as the new transportation and economic axis for the Boston metropolitan region.

Within a few years of the completion of the northern section of the new Route 128, several major industrial parks developed by Cabot, Cabot and Forbes sprang up on former farms in close proximity to major interchanges. The first was the New England Industrial Center in Needham; this sign advertises the availability of sites in the Peabody Industrial Center near the current Interstate 95 interchange. (Courtesy CC & F.)

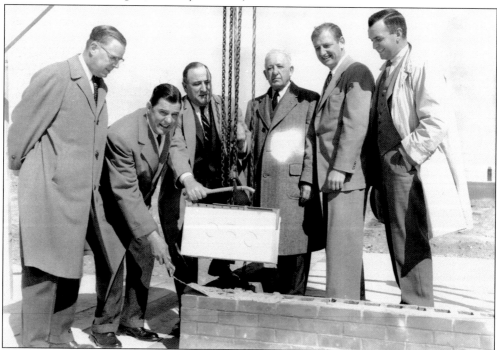

In this image, officials from Cabot, Cabot and Forbes, Aberthaw Construction, and Goodyear Tire Company lay the cornerstone for the new Goodyear building in the New England Industrial Park in Needham. Goodyear's former headquarters was an inefficient multistory concrete and brick warehouse structure on Jersey Street in Boston's dense Fenway neighborhood. A modern, single-story suburban showroom and office facility with easy highway access proved preferable. (Courtesy CC & F.)

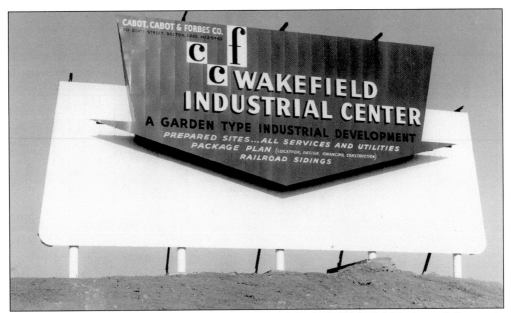

This billboard marked the site of Cabot, Cabot and Forbes's Wakefield Industrial Center in the spring of 1959. Of particular note is the inclusion of railroad sidings in the list of amenities provided as part of the development package. Although car-friendly suburban locations appealed to plant workers, many producers still relied on rail access for transportation of raw materials and finished goods. (Courtesy CC & F.)

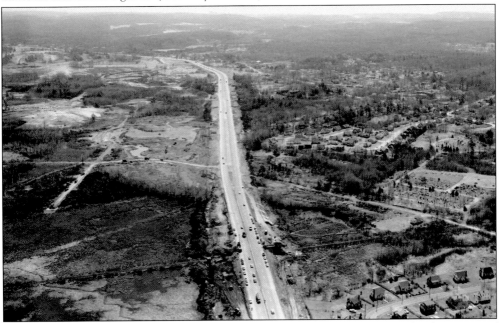

To the left (north) of the new highway in this April 1959 aerial view is the future site of the Wakefield Industrial Center. To the right (south) of the highway are new residential subdivisions that sprang up in the years immediately following the highway's construction. Along the southern side of the right-of-way is land that has been cleared as part of the widening project that began in the spring of 1959. (Courtesy CC & F.)

Also accompanying the construction of Route 128 through Wakefield was the $4 million Pleasure Island amusement park, which at the time of its completion in 1959 represented an early attempt to imitate the successful Disneyland theme park in California. The park ultimately fell victim to the new highway's rapid evolution into a nexus for commercial and industrial (rather than recreational) activity. The park closed in 1969 and was rezoned for industrial use. (Photograph by David Yetman.)

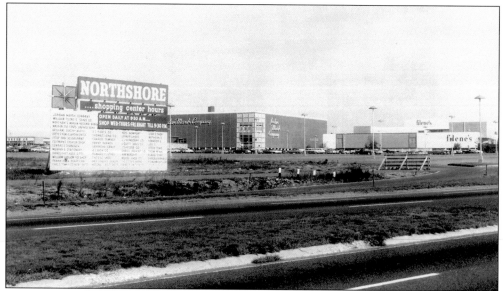

Industrial parks were not the only land-use innovation pioneered in part by Cabot, Cabot and Forbes to follow the construction of the new Route 128. Regional shopping centers like the Northshore Mall in Peabody (pictured here) brought high-volume downtown department stores and smaller boutiques together in convenient, automobile-friendly locations easily accessible to suburban dwellers. (Courtesy CC & F.)

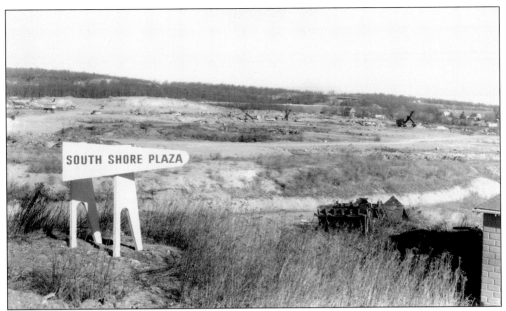

South Shore Plaza was another of the regional shopping centers developed by Cabot, Cabot and Forbes in the years immediately following the construction of the new highway. Here, in the spring of 1959, a somewhat prematurely placed sign just off Granite Street in Braintree points the way to the future site of South Shore Plaza as earthwork and utility installation proceeds in the background. (Courtesy CC & F.)

The old Blue Ridge Farm in Braintree is shown in 1958, shortly after it was purchased by Cabot, Cabot and Forbes to make way for South Shore Plaza. In the decade following the construction of the new Route 128, with New England's agricultural industry long in decline, developers found many farm owners from Gloucester to Braintree eager to sell their properties at the inflated prices that proximity to the new highway commanded. (Courtesy CC & F.)

This billboard marks the site of the Northwest Industrial Park in Burlington just north of the Route 3 interchange with Route 128. The Nordblom Company and the GBH Macomber Company developed the site, which at the time was one of the first major commercial developments in the town of Burlington, which rezoned large tracts of land in the 1950s and 1960s with the specific intent of attracting large-scale commercial development. (Courtesy MSA.)

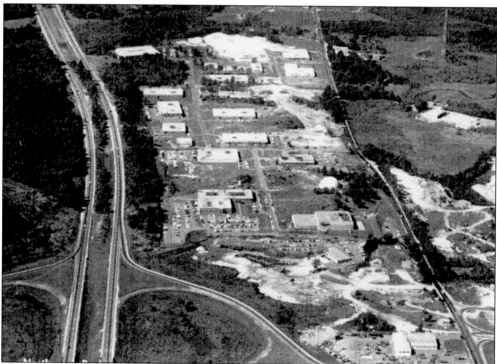

This northerly view of the Northwest Industrial Park shows its early years, when it housed a variety of industrial concerns, including RCA. A Filene's department store that the town of Lexington voted against in 1958 was welcomed with open arms by Burlington and became the anchor for the Burlington Mall, for which construction is just beginning at the far right of this 1967 photograph. (Courtesy the Town of Burlington.)

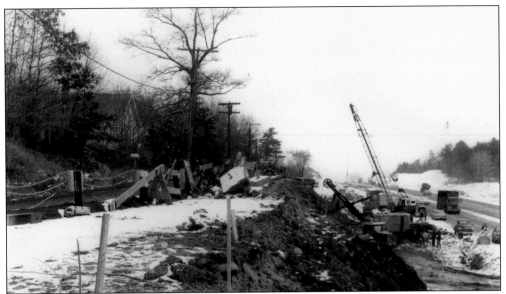

In 1962, the Massachusetts Department of Public Works began widening the existing four-lane highway in the Lexington-Burlington area. In this view, the embankments on the northern side of the old highway in the vicinity of Robinson Road in Lexington (left) are being cut back to accommodate the widening from four lanes to eight. In all, some 27 miles of highway were widened from Wellesley to Lynnfield between 1958 and 1964, at a cost of more than twice the original roadway. (Courtesy MSA.)

This image shows the nearly complete widened and resurfaced Route 128 in the vicinity of the newly constructed Route 3 interchange in southwest Burlington, an area that soon became the site of some of the densest development anywhere along the new highway. Here, on an early morning in September 1964, an awkwardly parked dump truck gives motorists on Route 128 northbound a taste of the future. (Courtesy MSA.)

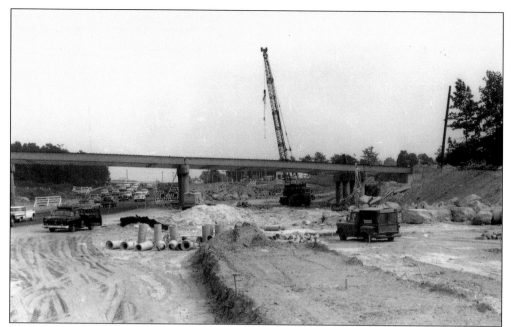

In this August 1962 photograph, Route 128 in Newton is being widened to accommodate eight lanes of traffic. The superstructure of the new Grove Street bridge is nearly complete, and fine grading of the roadway bed itself is proceeding in the foreground. (Courtesy MSA.)

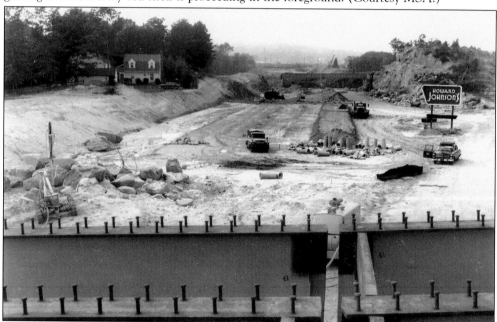

This northerly view from the partially completed Grove Street overpass shows the widened highway's new alignment, which ran just west of the old four-lane route (far right) to better accommodate the interchange with the Massachusetts Turnpike Extension, also under construction at the time. Among the businesses that had to be removed to make way for the wider route was a Howard Johnson's, the sign for which remains in this August 1962 view. (Courtesy MSA.)

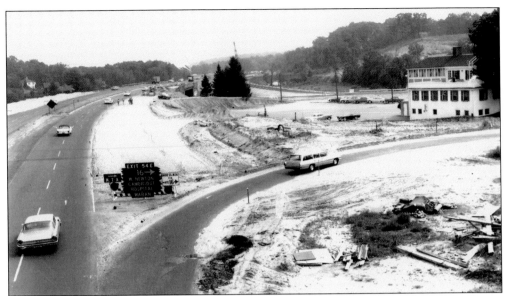

The highway is being widened near the Route 16 interchange in Newton, with the Pillar House to the right in this southerly view from 1962. When the new off-ramp (in the distance) was constructed around the Pillar House, the Massachusetts Department of Public Works provided direct access from the ramp into the Pillar House parking lot. Forty years later, MassHighway cited safety concerns stemming from the unusual access that its predecessor had provided as justification for taking the Pillar House property by eminent domain. (Courtesy MSA.)

Among the most complex aspects of the widening program was the construction of new overpasses alongside the existing ones in order to keep local traffic flowing smoothly during the work. This April 1962 view, looking north, shows the new Route 16 bridge under construction in front of the old structure, which will carry local traffic until the new bridge is completed. (Courtesy MSA.)

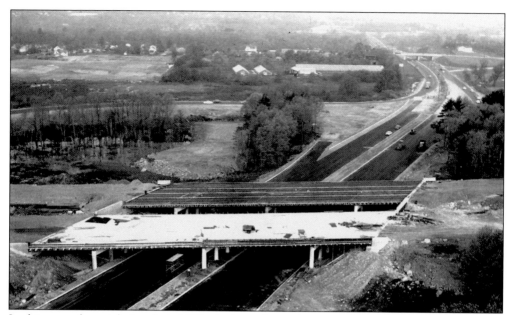

In this westerly aerial view from 1959, the interchange between the newly widened Route 128 and the new Interstate 93 is under construction in southern Reading. The opening of Interstate 93 the following year almost immediately resulted in traffic volumes that exceeded the efficient capacity of even the eight-lane Route 128, and the interchange has been one of the region's most congested ever since. (Courtesy the Reading Historical Society.)

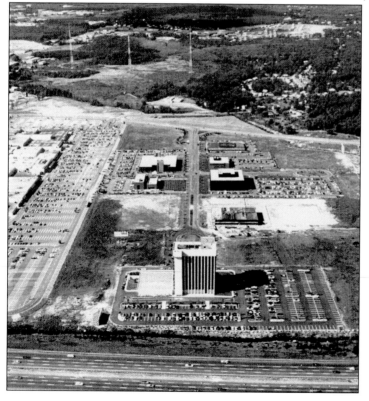

This view of the New England Executive Park in Burlington demonstrates the fundamentals that made sites along Route 128 so attractive to the region's development community—high land ratios, convenient highway access, and ample surface parking. Of note in this view is the unusual high-rise Middlesex Bank Building, constructed in the early 1970s. Visible to the left is the Burlington Mall, which opened in 1968. The towers in the distance are for WRKO, a Boston AM radio station. (Courtesy the Town of Burlington.)

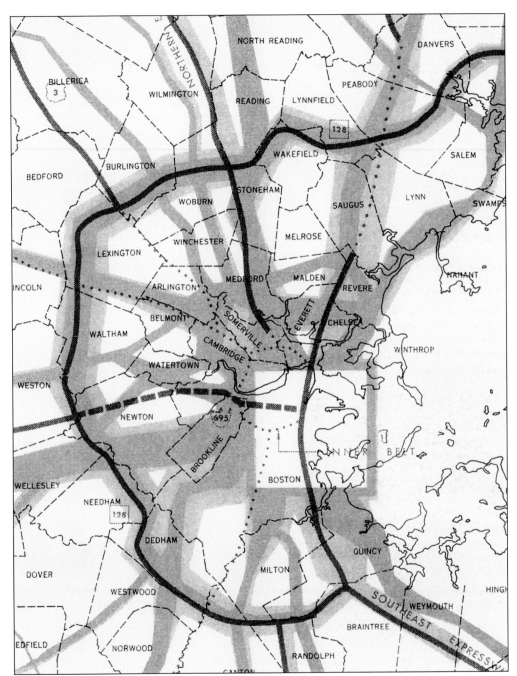

The result of the explosive commercial development along Route 128 is shown in this diagram, in which the shaded areas illustrate the volume of traffic flow in the Boston metropolitan area in 1960 (the downtown area has been left blank for clarity). Compare this figure to the projection on page 27 and note that regional transportation planners in 1930 completely overlooked the potential for increases in circumferential traffic flow in the region, because the traffic forecasting methods of the day failed to take into consideration shifts in population density, land use, and the impact of new highway construction.

SOURCES

The following list includes the sources of direct quotations and anecdotes that have been included in this work. It is not intended to represent a comprehensive list of research sources. For readers interested in a complete list of citations to images included courtesy of the Massachusetts State Archives, please reference www.buildingroute128.com.

MAGAZINE ARTICLES
"Boston: Building in History's Attic." *Business Week*. July 10, 1954.
"Boston Makes a Comeback." *U.S. News and World Report*. September 21, 1964.
"Center of a New World." *New Yorker*. 1963.
"Is Boston Beginning to Boil?" *Fortune*. June 1957.
"New England Highway Upsets Old Way of Life." *Business Week*. May 14, 1955.

NEWSPAPER ARTICLES
"2 Submit Same Bid for Home." *Boston Herald*. March 21, 1950.
Bartlett, K.S. "Granite Ledge, Marsh Problems Stymie Last Route 128 Section." *Boston Globe*. February 17, 1952.
"Big Express Highway Seen Opening Many New Areas." *Boston Globe*. November 14, 1949.
Harris, John. "Of All Callahan's Highways, Route 128 Seems to Be It." *Boston Globe*. July 22, 1951.
Hinkle, Alice, and Diana Brown. "Route 128, 60 years of stop and go." *Boston Globe*. February 18, 1996.
"Homes Showered with Rocks." *Boston Herald*. September 6, 1950.
Mills, Edgar M. "Route 128 Rouses Debate." *Christian Science Monitor*. March 11, 1955.

OTHER SOURCES
Interview with Gerald Blakeley. December 17, 2002.
Levitan, Donald. "Highway Development and Local Government: An analysis of relationships—a case study of Massachusetts Route 128." New York University, 1972.
Report of the Metropolitan Park Commission, 1911.